THE MASTER PLAN

Stephen Hodge

Book Works / Situations

WESTON-SUPER-MARE

THE MASTER PLAN

WESTON-SUPER-MARE.

A GARDEN CITY BY THE SEA.

THE MASTER PLAN.

Meeting of Townspeople Held in the

King's Hall,

Friday, January 24, 1947.

Chairman : His Worship the Mayor,

Councillor G. E. Bosley, J.P.

Speaker : The Hon. Lionel G.B.Brett,

M.A., A.R.I.B.A., Partner

with Mr. Clough Williams-

Ellis, M.C., J.P., F.R.I.B.A.,

M.T.P.I., Town Planning

Consultant to the Borough

Council of Weston-super-Mare.

(Transcript of Shorthand Notes Taken by
H.G. Venning.)

The Mayor : May I first of all, as Mayor, say how pleased I am to see such great interest has been taken in the "Master Plan" for the future of Weston. I do not think it can ever be said again that the Ratepayers of Weston are apathetic when the future of their Town is at stake, and it really is a delight to have such a packed house as this. I am only sorry that Mr. Clough Williams-Ellis is not here to see the enthusiasm which has been aroused. Unfortunately, a sudden and severe attack of influenza laid him low yesterday, and it was just impossible for him to travel to Weston to be here to-night. Fortunately, we have with us the Rt. Hon. Lionel Brett, A.R.I.B.A., a partner with Mr. Williams-Ellis, and, if I may say so, the one who has actually worked out the details of Weston's Plan. I am not going to take up the time of the meeting any further, and will ask Mr. Brett if he will now proceed to outline the Plan.

7.5 p.m. The Rt. Hon. Lionel Brett : Your Worship, ladies and gentlemen, I would like to say on behalf of Mr. Williams-Ellis he is extremely sorry. His last words to me were that it was a bitter disappointment to him, having to miss this evening's meeting. It was just one of those things which do happen, and I, personally, feel as strongly about it as anyone, as I am left to carry the baby, or whatever it is. (Laughter). We are really now at two jobs, so to speak, and although I think the old aeroplane will be able to limp home on one engine you wont get the show of aerobatics that you would have had if Mr. Williams-Ellis had been here as well.

This meeting is really something quite new in the experience of townplanners, as far as I know. Formerly, a Consultant is called in. He produces his plan and his report, and it is handed to the Council, and the man in the street knows nothing much about it until it is published in an expensive-looking book, which he may or may not be able to afford to buy. And he has to make the best of it. Your Council decided that before the Plan was finalised, while it was still possible to make changes in it, the public opinion of Weston should be consulted, and I think that is an extremely wise decision. It means a great deal to us, because we can feel that when, finally, the Plan is drafted it has got in essence public opinion behind it, and it may, in fact, embody quite a lot of ideas which had not occurred to us. So you must realise when I show you one or two pictures of re-planning that you are being taken, as it were, behind the scenes to-night, and shown a plan half-finished. You wont get beautiful pictures and perspectives, etc, with which architects are accustomed to dazzle their clients. You will get a rather rough and ready sort of drawing, because it was not worth-while wasting time on finished drawings if it was possible considerable changes might be made. So you are coming behind the scenes. I shall try to tell you how our mind has worked and explain how the project has grown.

I would like, before coming down to details, to utter one word of warning, or, rather, of consolation. By which I mean that you must not be frightened by this Plan. It is a long-term Plan. It does not mean that your house is going to be pulled down tomorrow, and turned into a public lavatory, or a shop, or an open space. We are trying to think 30 years ahead. It is a 30-year Plan. It simply

1 Postcard (front depicts Anchor Head, Weston-super-Mare) bought from Exeter Antiques Centre (August 2011).

means that a great deal of development is going to take place anyhow,
and that development can be plan-less or it can be planned. If it is
planned it is done in accordance with an over-all outline scheme to
ensure that everything that is done is good for Weston, instead of
being bad for Weston. And that is what the Plan is. It is an
outline development plan, designed to ensure that whatever happens
is right and not wrong. Nor is it a final Plan. We have been asked
by the Council to produce ideas for their benefit. They may like
them, or not. If they like them they will incorporate them in their
own proposals which will be put on the new plan to be laid before the
County Planning Authority. In turn, the County will put them up
before the Regional Representatives of the Ministry of Planning.
So it has a long way to go still. It is only in its infancy, and
there is no need to feel that whatever you see on the screen is by
any means final.

But I do feel that the decision to make the Plan is a most important
one. Weston is about 100 years old, and the time has come to take
stock of the town, and decide what can be done to improve it now that
so much re-building is inevitably going to be done next anyhow. One
must remember that other places, possibly competitors of Weston's,
are all busily doing the same, and this place cannot afford--it is a
case of competition--one cannot afford to be left behind. So that,
the decision to plan having been made, by the Council called in Mr.
Williams-Ellis to advise them as to the outlines of the Plan. The
Planner is rather like a doctor : He takes a look at the patient,
notices the patient's strong points, his weak points, and gives the
patient a general overhaul, and prescribes certain medicines, which

GENIUS

The planner's first approach to his task is to sum up the personality of the city which has been put under his care. A city has the same right as a human patient to be regarded as an individual requiring personal attention rather than abstract advice. That is the first thing the planner has to remind himself of. The second is that abstract principles of town planning do not in themselves produce a good plan. The good plan is that which will fulfil the struggle of the place to *be itself*, which satisfies what a long time ago used to be called the Genius of the Place.

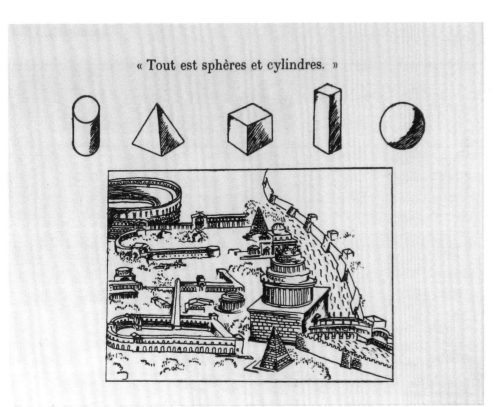

« Tout est sphères et cylindres. »

2 'Genius' by Thomas Sharp, from *Exeter Phoenix: A Plan for Rebuilding*, an unrealised post-war master plan for Exeter, published by The Architectural Press (1946). Second-hand copy, with marginalia detailing the actual post-war redevelopment written over twenty-one years by an unknown Exeter resident, bought from Exeter Rare Books by Stephen Hodge (January 2004).
3 Le Corbusier's illustration from the article 'Sur la plastique I. Examen des conditions primordiales' in *L'Esprit Nouveau: revue internationale d'esthétique*, No.1 (1920).

may be quite pleasant to take, and do a great deal of good in the
long run. Before we take a look at the patient, and the medicine --
Can everyone at the back of the hall hear what I am saying, because
this is the kind of tone of voice I was going to use. If it is not
of any use I will use another. Is this mike all right ? (Voices :
Yes.) Right. If we may have the lights out we will start looking
at the patient. (Lights extinguished).

That is a drawing of Weston as it is now--drawn this way to show in
black its built-up areas, and all sorts--they may be houses or shops
or factories, etc. It shows in green various kinds of open spaces--
dark green the public open spaces, middling green the private open
spaces, and pale green is the agricultural land, or other land so
far unbuilt on. The first thing that one realises as one studies
Weston is that the town developed roughly from here (indicating.)
This was the beginning of Weston about 100 years ago, in this
sheltered corner, near the whisper of the sea. A few terraces were
 end of the 19th Century
built about the ~~18th×19th×Centuries~~ for people who liked sea air,
which was just coming into fashion at that time, and owing to the
great natural amenities of Weston and the healthy air blowing in off
the Bristol Channel the place grew, and its growth, which was quite
plan-less, the result of speculation and people buying bits of
agricultural land and building houses on them, went roughly in two
directions. It went eastwards along the southern slopes of Worlebury,
and then went southwards, naturally, along the sea. So that, early
on, Weston began to assume the shape of a bow, with a right-angled
bend. Gradually, as the 19th Century wore on, the development went

eastwards until it came close to the old village of Worle and the sea
and another old village of Uphill on the south. So that one began
to visualise Weston in three parts--the main twon, with its bow-like
form, and the two villages of Worle and Uphill. Meanwhile, the
inside of the bow, the hinterland, remained empty and unplanned--
rather, the town's back door--and this tendency was rather accentuated
when the railway arrived, and the loop of the Great Western Railway
further accentuated the tendency of the town to leave its hinterland
undeveloped, and to spread outwards at its two ends. That, of course,
was not a final tendency. Roads, of course, as everywhere, ran where
they happened to suit. The main road from Bristol threaded a series
of suburbs, penetrating into the heart of the town, and another road
through Uphill village was extended along the Sea Front, and formed a
magnificent front to the sea. These roads, of course, in due course
encouraged ribbon development, and houses spread out along them in
both directions more or less indefinitely. But ribbon development
was less serious than to the north because there were a series of
private open spaces which kept development within bounds. All roads
met, so to speak, on the grip of the bow, where, of course, shops, hotel
hotels, municipal offices, cimemas, cafes and all the fun and games
of a major seaside resort finally accumulate. That is roughly how
Weston grew, and you can see that it has its good points and its bad
points. Its great assets are, of course, its magnificent position
between high ground to the north--Worlebury-- and Uphill and Bleadon
Down to the south, and its superb Sea Front, The richly wooded area
there (indicating Weston Woods), and, of course, it has other
advantages which I need not remind you of. At the same time, it has

its snags, and that is where the planner begins to sit up and take
notice, because these are the things he wants to get rid of. There
are some snags which we cannot get rid of, or do much about. There
was a celebrated tide which, we said, said did not fall in the terms
of reference. (Laugh.) But there are plenty of man-made snags
which can be dealt with, and as this Plan unfolds I think you will
be able to visualise how we want to deal with them.

I am going to take the Plan on five or six different headings.
The first one, and I think it is the logical one to take first, is
the residential lay-out : Where people live. There are four sorts
of residential lay development in Weston, and there is nothing very
peculiar about it. It is worth noting what they are. There is
what is left of the old village centres. There are still fragments
of Old Weston at the centre--a few cottages--and considerable remains
of the old village of Worle and of the old village of Uphill. These
are country cottages, swamped rather in their later development, but
at Worle and Uphill still preserving characteristics of the old
village, which we want them to keep. The next arrival on the scene
was in the early 19th Century--blocks of terraces, large and small,
in this area at the centre of the town. Most of them now are
obsolete for various reasons--they are too big, or too small, or too
congested. The next development is that of the large houses in what
were then suburbs--the Shrubbery Walks area, south of Weston Woods--
and down here, in the area of Clarence Park. Large detached houses,
with big gardens, many of them in lovely situations, but large numbers
of them difficult to use under modern circumstances, and tend to be
split into flats, for which they are not at all suited. Lastly,

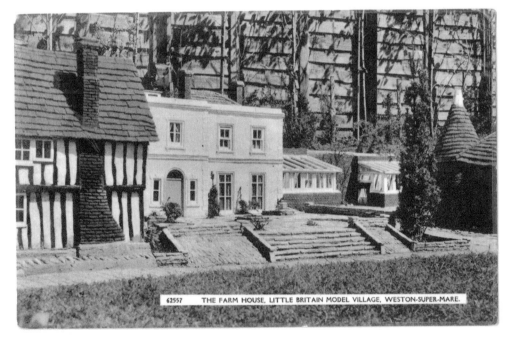

62557 THE FARM HOUSE, LITTLE BRITAIN MODEL VILLAGE, WESTON-SUPER-MARE.

4 Weston-super-Mare reconnaissance, photographed by Phil Smith. A palimpsest of past theatrical worlds awaiting scenographic regeneration for a new production, impromptu visit to The Theatre In The Hut in Milton Lane by Stephen Hodge and Phil Smith (April 2010).
5 Front of postcard depicting Little Britain Model Village, Weston-super-Mare, bought from Exeter Antiques Centre (October 2011).

6 Forelands, Weston-super-Mare, photographed by Max McClure from a north-easterly position (October 2010).

the fourth type is the 20th Century suburban houses, of which there
are large numbers, as you know, in the area of Milton, spreading out
towards Worle, a few around Uphill, and, of course, around the front-
fringes
ages of the town on either side, the usual semi-detached and other
suburban houses with which we are quite familiar. That is the
residential set-up as it is. What are we going to do about it ?
Before we can discuss any of the residential areas we have to decide
how great these extensions are to be : How big we want Weston to be
in the future. That is a problem to which no definite answer can be
given. We can only look back over the population figures of the last
20 or 30 years and see what Weston seems to be doing and becoming.
If we do that, we find that the population has been growing slowly
but steadily. Ignoring any increase due to boundary adjustments,
which would give a false picture, it seems that the population has
increased at the rate of just under 1 per cent--0.8 per cent.-per
annum. Whather that should be accepted as a guide for the future
is, of course, a problem on which anyone may have their own views.
It may be the national population is not going to continue to increase,
in which case it is difficult to see why the population of Weston should
continue to increase. On the other hand, if we become prosperous, and
the national income increases, the chances are that more people will
be able to afford to retire, and many of them will retire to Weston.
So that these two things seem to lead opposite ways, but probbaly
the safest thing is to assume a continuous rate at the slow rate of
0.8 per cent., in which case in the 30 years covered by the Plan we
shall get an increase of about 10,000, which is an easy and rough
number. 10,000 more people, bringing the town up to about 50,000,

which we take as the figure for planning purposes. In addition to this 10,000 we have to remember that a comparatively small number of people will have to move from the central, congested areas. They have to be re-built into new houses on the outskirts. There are certain points which are obviously low standard and which can suitably be re-developed for municipal and business rather than residential purposes, in which case thse people will have to go elsewhere. We think they number 2,000. We have 12,000 people to be housed on new residential land. One other thing while we are on this question of population which we take into consideration is the structure of the population : Whether it consists largely of men, or women, or children, or what ? Weston, in common with other resorts, has a population structure which is different rather to that of the ordinary inland town. There is a larger proportion of the very young and the old and retired, and a smaller proportion of middling-age groups, 30's and 40's. The very young--I mean really young people, in their 'teens--many of whom work in hotels in the season. There is a large proportion of hotel people in Weston. In planning, we want to take these people into consideration. For instance, flats in reasonable numbers are obviously desirable for many of this sort of people rather than houses. These are the deductions which we make from the figures of population.

Now, for our proposals for the siting of these new residedtial areas. We take as an average residential density for new areas--i.e., we assume that roughly 24 people live on an acre. That is very loose, and not at all tight. They will be living quite comfortably at 24 persons to the acre--some naturally tighter, and some looser. These

12,000 people will need about 500 acres for houses, gardens, access
roads. Where are we going to find these 500 acres ? We will now
come to another thing (fresh slide here). At the moment, it is a
very confusing picture and it need only be considered in relation to
this picture of residential areas.. I do not want much detail.
Can you see at the back ? I shall have to assume you can see
these main lines. We first remember the extension of the town is
that it is done by down slopes, of houses in the country, but we leave
them to get on as best they can. You have to consider the point-
of-view of people who live there : They want to get to their shops,
schools, work, easily and quickly, and safely. Naturally, your
development must either be XSIISWIKSXSKX filling out existing going
concerns or you have to make new small communities. We have done
both these things. To take the going concerns first. You remember
at the beginning I said that Weston consists in outline of three
elements : Weston Town, and Worle suburb and Uphill suburb. We
take these three, and start by seeing if we can fit any more houses
in there without overcrowding them. What we take as the centre of
Weston is this : It is land running along the south of Weston Woods,
and includes Milton suburb, and stops well short of Worle, and then it
is bounded by the railway--it does not extend beyond the railway to
any appreciable extent--and then comes down, sticking to the loop.
The Great Western includes certain new developments here. And then
to the sea, just north of the County School. If you call that Weston
Town, it is very much built-up, but you can get inside the following
new housing areas--I would like to divide Weston Town itself , which

VOLUNTEERS NEEDED AT SECRET WORLD

TOMORROW UP FOR GRABS!

Something is wrong

Eskimo Plea against Airport Expansion

7 *Weston & Somerset Mercury* headlines (20 March 2009, 8 January 2008, 5 June 2006, 13 August 2007, 30 September 2010, 19 November 2007, 23 July 2009 and 18 April 2007).

Human head and bones found on beach

VIEWS WILL BE GONE FOREVER

Investigating Plan B

THE VIKINGS WILL BE BACK

is a large area, into three, with possibly four : One, the north area
of Weston Town can be divided into the Shrubbery Walks area--here,
Milton--the town centre--and, number four, still in process of
development, and hardly completed, Bournville Estate to the east.
The Shrubbery Walks, however, is a special problem of its own, with
its big gardens, flowers and trees. It looks attractive, but a
great deal of property there is not suitable for its present use.
However, it will never seriously d̶e̶p̶r̶e̶c̶i̶a̶t̶e̶ deteriorate, because it
has such natural advantages, with its sunny slope, magnificent views,
and it is a place where private enterprise could be allowed to re-
develop in an imaginative way, partly with flats and partly with
houses. We want the larger houses together, and there is no doubt
that areas like that in London and Provincial towns have been found
ideal for re-development, about 50-50 houses and flats--no great
sky-scrapers. Milton, which is a shapeless sort of place, is
bounded locally on the notth by superb open spaces, and it obviously
must end there. To the south, the Locking road is its natural
boundary, and to the east what little open space remains between it
and Worle must be jealously guadded to prevent the two coalescing.
We find in that area we can find another 30 acres for housing at medium
density. By density, I just mean the number of people per acre ;
when I talk of high density I mean 20 per acre ; you will get 8 and 12,
and as low a one as 6. 30 acres in Milton. We have dealt with the
 do not
Shrubbery Walks area, into which we/reckon we can get any new houses.
Milton, we say, can take 30 acres. The old Town : It can get another
11 acres. It is difficult to see, but it is there, south of Locking
road, and north of the railway, in a position which will become

clearer later, and which will be mostly flats. Ashcombe road and
Earlham Grove, north of Locking road, at present an undeveloped area :
We can get in 35 acres at medium density, mostly houses. And,
lastly, in Weston proper : The Municipal Estate at Bournville, at
present in process of expansion, will finally, with its extensions
in this direction and there, provide 120 acres of new houses--that
is, post-war houses--at medium density. So much for the Old Town.

Worle : Worle is now effectively by-passed on the south, and,
luckily, does not get a great deal of through traffic for that reason.
We would allow some extension of Worle to the west, very carefully
bounded to see that it does not run into Milton, and a rather more
considerable extension to the east. A certain number of small
pockets to the south can be filled up, so long as development does
not ribbon along the main road. Development is halted well clear
of the road, and not lining it, so that the road runs through open
country. Assuming that extension of Worle until it becomes fairly
stiff we can get in 80 acres, at middling density.

Uphill we want to retain as a suburban place, with its own village
character unspoiled. It can take a certain amount of new houses
to the east, stopping again short of the Bridgwater road and not
lining it so that the road is a pathway and not lined by houses. By
filling out in that way, mostly to the east, in Uphill we can get
another 55 acres there, again at medium density.

We have covered the three units of Weston, Worle, Uphill. Is
there any more we can do, because we have 500 acres to find ?
Milton Hill : This magnificent, windswept position can be filled out.

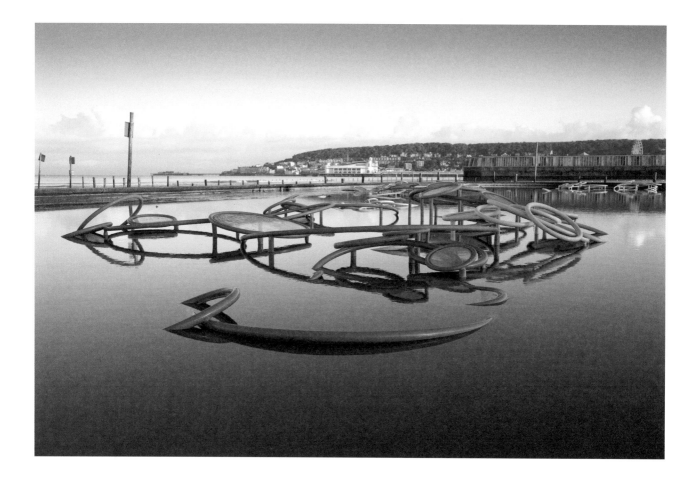

8 Ruth Claxton, 'And my eyes danced', 2010, commissioned for *Wonders of Weston* by Situations and Field Art Projects as part of North Somerset Council's Sea Change programme for Weston-super-Mare, photographed by Jamie Woodley (November 2010).

There are obviously plots there which are ready to be built on, and it can to some extent be filled up. A matter of 20 acres or so can be found there for development at low density. It is strictly bounded on the west--not allowed any further into the Woods--and on the other. This land is unsuitable for developmentm and we do not want any development in this direction, which is difficult owing to trees.

Worle Moor : This is something new. An area at present agricultural, rather low-lying, but suitable for development as an independent small community. We suggest there that the Council should acquire about 100 acres and lay it out as a small community of its own, with shops, cinemas and other local amenities--open spaces, of course, school--and it would house something like 2,000 people.

I have already dealt with Bournville under the heading "Old Town." The next one is Bleadon Hill. The situation of Bleadon Hill is rather similar to that of Milton Hill. There is a certain amount of untidy, sporadic sort of development dotted about there, not improving the landscape in any way. There it is, and it has to be accepted. The only thing for it is to try to pull it together and fill out the spaces to try to create a village in that area, quite aeparate from Weston, with its own little shops in the centre. There we full out to the extent of 50 acres.

Lastly, we show here (indicating) a small blob out in the wilds, a place called Castle Batch. It is at the moment not possible to develop there for drainage reasons, but ultimately it can be made possible, and we would not mind seeing a village built there. It could be done by Council enterprise or by private enterprise. We do

not want dotted all desirable residences in that area, but a village, thought and planned on village lines, and not as a Council estate. It could be attractive. It could take 500-600 people. That adds 500 acres, and it could be done without covering the whole of the hollow up with houses, eight to the acre, leaving a considerable stretch of rural land surrounding it and the different units of which it is composed. As for types of development in these areas, we say get them mixed up properly. We do not want miles of the same thing. If it is houses, the large and small should be suitably mixed in the proportions in which they are wanted, and not crazily mixed, but in some kind of planning ideal. That, on the whole, means something, and it is not just a mess. We do not want to go into any further detail about that, but I would like to see large houses built among the small from the start. We do not want to put all small houses in one area, and, if the Government permits it, we want large houses put on the Council estates. So much for the residential lay-out.

I think this is the point to mention open spaces. Weston is, of course, very rich in beautiful parks and open spaces. If you take any standard by which we try to judge towns as regards open spaces you will find that Weston has more than is considered necessary for the average town, as, indeed, it should have as a seaside resort.
For the population of 40,000, which is its approximate present population the ideal of open spaces is 280, not including schools ; that is the figure which would be accepted by planners. Weston has 615, which gives you an idea of how rich Weston is in open spaces. There is no question of buying large tracts of country for public open spaces and parks. The only serious deficiency in Weston is public

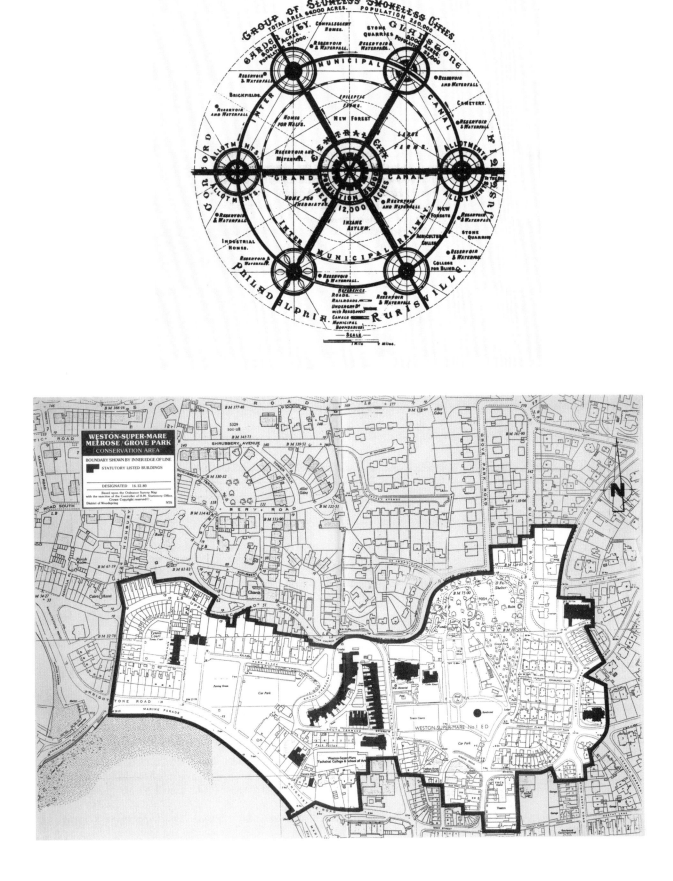

9 A garden city model by Ebenezer Howard from *To-Morrow: A Peaceful Path to Real Reform* (1898).

10 Melrose/Grove Park Conservation Area map, sourced from North Somerset Council (August 2010).

playing fields, and we have provided for them, as I will mention.
Let us first take parks, and what you call the amenity of open spaces.
Weston Woods is, of course, the crown, and at the moment not treated as
such. It is almost impossible for a stranger to find his way to the
Woods, and when he finds it it is covered with ivy, and trees dying,
and, as is inevitable after seven years of war, of neglected appear-
ance. I know the Council is most keen to get on with the regeneration
of Weston Woods, and I hope it will employ a qualified forester to
do so. (Applause.) I feel that something must be done about the
access to Weston Woods, and what we propose is from the northern end
of Grove Park it should be easy and simple to walk on a road which
leads north from there. That road, which turns sharp right, has a
pedestrian path, a terraced path, with steps and little pathways, and
benches, and every amenity for comfort. And leading straight up to
the left of the Quarry into the Woods, so that from the High Street
you look straight up through the trees of Grove Park, and the stranger
would say, "That looks like Weston Woods," and he would walk up into
the Woods.

The Grove Park, itself, is, of course, one of the most attractive
parks of Weston, beautifully planted, and naturally it stays as it is.
Ashcombe Park : Again, a magnificent open space, not technically a
public open space, but we hope it will at once be declared as such.
Ellenborough Park is not a public open space. It is in so important
a position that, again, we regard it as vital that the Council should
acquire this Park as a public open space. (Applause.) Clarence
Park : Again, an extremely valuable public open space. More can be
done to develop its playing field side, and, especially, provision for

children, and, as will be seen later, both these Parks, Ellenborough
and Clarence, are united by the disappearance of Walliscote Road. I
will come to that later. (Laughter.) I did not know Walliscote
Road was so popular.

Uphill Down is, again, a superb open space, and we do not want to
see anything done to it--no planning, or building refreshment kiosk.
Leave it as Nature built it. (Hear, hear.) We hope in all resid-
ential development there will be small gardens as part of the lay-out.
We much prefer a small, two or three acre, garden, really well main-
tained, and well planted, to a large desolate park. You will find
little blobs all over the place where these gardens may go.

And, equally, playing fields. For reasons I will come to very
soon it is going to be very necessary, if our Plan goes through,
for the Rugby Ground to go elsewhere, and we have rather fallen for a
proposal that has been put up to us, that/the big Weston Quarry, which
in due course--not very long, I gather from now--will be worked out
a dignified and natural stadium, rather like the Greek amphitheatre,
can be got in. The green would be about the size of Wembley, and free
seating could be built into the side of the hill. It is only a rough
idea, but it would provide a magnificent feature and would take care of
jobs which are at the moment done elsewhere. That would be Weston's
main sports ground. (Applause.) But, apart from that, there is a
crying need for sports grounds in suitable places in every built-up
area. At the moment, there are two main sports grounds, apart from
the Rugby Ground--a five-acre ground at Worle, and a four-acre ground
at Uphill. We propose they should be supplemented by five-acre
grounds at Worle Moor, at Locking Road, at Uphill Junction, and a

12-acre ground adjoining the new main road. That would considerably
increase the acreage of playing fields, and should be adequate. Apart
from these, we hope that little children's playing grounds will be
liberally dotted about in all residential areas, within easy child's
walk of any house. (Applause.) Particularly, of course, those areas
where gardens are small, or non-existent.

Private Open Spaces : We show certain ones in a middling shade
of green, and it is vital that these should be duly scheduled as
private open spaces, and preserved as such permanently. Some of the
private open spaces, particularly the two golf courses, are just as
important to Weston's amenities.

Allotments : Allotments are a difficult problem. It is difficult
to know how much Weston should have. The principle we have gone on
is to avoid large allotments, which are always depressing features,
and to distribute the allotments in some penny packets all over the
residential areas--so small that you will hardly notice them at this
scale. There is only one large one ; that already exists. Others
have been provided to the extent of eight acres altogether. Whether
that is adequate or not you will be able to tell me. That is enough
about residential areas and the open spaces which surround them, except
you will note, and I will mention it again later, that along the roads
there are green strips which should be planted with xxxxxxxxxxx big
trees, not little prunus or peach trees, but big trees, allowed to grow
to their full size---(Applause)---so that Weston, which, at the moment,
gives a tree-less effect, will no longer do so. We regard this
planting of trees as one of the most important aspects of the whole
Plan. (Applause.)

I come to the question of communications, by which I mean : Rail, Road, Air and Sea. Of course, the communications are really the backbone of your Plan. Literally, they are the arteries on which the whole thing lives, and the shape of the thing does not begin to appear until one has planned them. Let us take them in turn. Let us take first railway communications. Weston owes its prosperity partly to its excellent railway communications with London and the Midlands, and the only unfortunate thing about it, of course, is that the main line does not go through the town. Most trains that come down this line do take the Weston loop ; the majority go that way, rather than down the main line--and Weston loop is an unsatisfactory affair, very sharp just at the Station where you do not want it to be. We expect the Railway Company, as soon as practicable, to do three things to improve the Station. The first is to ease the curve, the link at Weston, flatten it back, and a bit eastwards, so that it is less sharp; to re-build the Station itself, which will be moved back with the line, and which needs re-building, anyway--(Laughter)-- and to build a small loop, which would back on to the main line. It would be possible for an excursion train, instead of reversing direction and instead of going back to Bristol, could carry on around the loop, and go back without any change of direction.

On that assumption, we make the following proposals : The Station. I think it will be clearer if we saw No. 3. (New slide). We are now working on a bigger scale, and now dealing with the centre of the town. Here is the loop, which is considerably flattened from its present position. That brown thing is the new Station ; it is long and thin. It is long because it will have to handle not only the

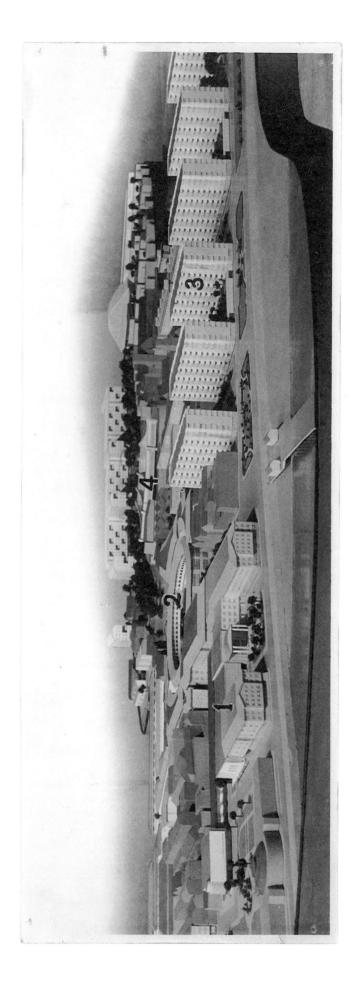

11 Unattributed photograph, perhaps of a model of Williams-Ellis' Master Plan from the *Design for Weston* exhibition, (opened by the Rt. Hon. Lewis Silkin, M.P., Minister of Town and Country Planning, in the Town Hall on 13 August 1947), found in the North Somerset Studies Library on Boulevard (July 2011).

normal traffic but the long excursion trains which, at the moment, park themselves along Locking Road. We are anxious that the whole of the goods and passenger platforms in this area should go elsewhere-(Applause). Therefore, this Station handles everything, and people arriving there will have quite a pleasant walk to the Sea. Apart from the question of the passenger and excursion stations, there is the question of the Goods Station, and that, we reckon, must go elsewhere. It is ideal from the planning point-of-view. It is handy to the industrial area which spreads out in this direction, and goods are handled, it provides for heavy vehicles coming into the town, and it has quick communications with the Town centre. The area previously occupied by the Goods Station and Excursion Platforms is laid out as a new residential area, mostly with tall flats. We hold no particular preference for flats, as opposed to houses, but if there are to be flats we reckon that is to be the place for them, because they are impressive buildings in themselves. When you arrive at Weston you want to think it is a big, fine place, and not just a pokey spot at the back of nowhere. Another thing laid out xxxk has been a residential areax of 11 acres.

So much for Rail proposals. As you will see, it involves displacing the Rugby Ground, and I have already dealt with where the Rugby Ground shall go. If we may xxfxx revert to Slide No. 2.

The Road question : Weston is fortunate in some ways in that it does not have through traffic to deal with. It does not have masses of motorists pouring through the place on the way to somewhere else. On the other hand, it has its own problems, inasmuch as everyone who comes in a car to Weston comes here for the day, stays in the place, and so,

though you do not get big through traffic, you get a big parking
problem. We will come to the details of parking later. Let us
take a look at the Road situation as it is. The really heavy and
load of traffic is, of course, borne by the main Bristol Road, coming
into Locking Road, which reaches the point of maximum at what is
called the Big Lamp, where other roads meet, and the problem is an
awkward one. Other roads : Of course, the Bridgwater by-road, coming
on the Sea Front--quite a good road, which we feel we need not worry
about, as far as re-building is concerned. B3127 comes in past
the Aerodrome, past Locking Village. A very useful road, and I
think it has an important part to play in future. The black spots
are the Big Lamp itself, the point on the Locking Road where the road
is narrow, with all the excursionists emerging from the dreary area
into the street and get run over, and Meadow Street, narrow, congested,
and unsatisfactory at the moment, and, of course, the country roads
gradients and sharp bends, Kewstoke Road, which badly need ironing out.

In general, the Weston street system is the result of a series of
developments without any relation between them, and the job is to try
and re-classify the streets, so that each is used for the purpose
for which it is designed. This classification : We say, and I think
it is accepted planning doctrine, thatbthere are three kinds of
streets really : Traffic artery--the big road which carries the long-
distance traffic ; it is concerned chiefly not with local traffic but
long-distance. Secondly, there is the local traffic road. This is
the road you take to get about the town, if you live there, if you want
to get from Worle to Uphill, or from the outside to the centre you
want a quick way of getting there, a local traffic road with the buses,

which, normally, will stick to traffic roads, will take you. It
joins up the various parts of the town. The third part is the access
road : Where you live, and shops are situated.

Traffic arteries : The main object of coming to Weston is to get to
the sea, and we assume that for some time people are going to arrive
as they do now, down the main road from Bristol. Of course, there
are far more exciting ways of coming into Weston. You could come
over the corner at the top, and over Bleadon Hill, but you must face
it that the bulk come from there. We have to get them to the sea,
and the way they go now is obviously not satisfactory. Locking Road
gets narrower and narrower and uglier and uglier as it goes on. We
make a new road through the Earlham Grove area, a double-track, through
to the point where the Milton Road comes down, and to where the new,
large roundabout is formed, and then along the existing street-Gerard
Road--into The Boulevard, which is still double-tracked all the way,
with a central reservation, 4ft. wide, and from the end of The Boulevard
we turn slightly to the right, over war-damaged property, into West
Street, which is widened, and so to the sea, just north of the Gros-
venor Hotel. That is an operation of no difficulty at all. Most of
the property is already either bombed or islanded by bombing, and the
area must be re-built. We do not reckon that when it is done it will
be anything to be proud of. It is ribboned almost the entire length
by building, and it is crossed with numerous side roads, and it is not
going to be particularly impressive.

We have other ideas, to which I will come. We call that "A" artery,
for future reference. The "B" artery. There is nothing sensational
at all about it. The new Bournville Estate is already laid out to

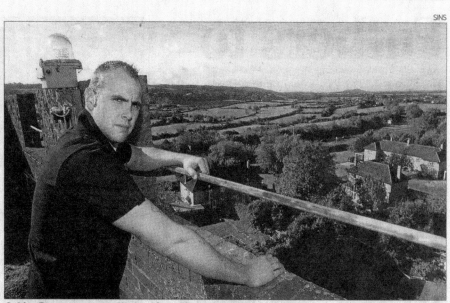

Ashley Parsons surveys the land from his tower, but none of the access routes belong to him

The home that can only be reached from the air

By Nick Britten

A FIRST-TIME buyer who paid £30,000 for a disused Ministry of Defence water tower to convert it into a home has found he can only legally gain access to it from the air.

Ashley Parsons, 20, wanted to turn the tower into a "modern and funky pad" for himself and his girlfriend Sasha Wareham, 21. But he has been told he would be breaking the law by walking or driving to it because it comes with no access rights and is on private land.

The company which bought the land around it from the MoD last month said it would not grant retrospective access rights because the directors do not want the tower to be redeveloped.

Mr Parsons said: "It won't stop me and I'm glad I went ahead with the purchase. The

The disused water tower

nearest public road to my house is 100 yards away but even though there is a connecting path I am not legally allowed to walk on it.

"A loophole in the deeds means there is a right of way for construction work. So while I'm refitting the tower

it's fine, but after I have finished I could be prosecuted for walking there.

"The only way I could access my home legally then would be to jump out of a helicopter or plane and land on the top of the tower. But this pathetic decision won't stop me from living in my own home."

Mr Parsons, an electrician, snapped up the 60-year-old, 150ft tower on RAF Locking, near Weston-super-Mare, Somerset, last month. His plans included an open-plan gym, lounge, and master bedroom.

A spokesman for Annington Properties, the former base's residents' management committee, said: "The directors of the management company have decided that it will not agree to vary the existing legal arrangements that restrict access to the water tower."

allow for a road here, and it is right that the hinterland should be
opened up, and the two ends of the bow joined up. That is the idea
of the "B" artery, which runs to the County School. It was at one
time thought a major road was going to pass through that area, carrying
traffic all the way from Birmingham to Land's End, but I underatsnd
the latest project for the regional road is that it should go further
inland--four or five miles in from Weston, in which cass this road
ceases to be of nationalmsignificance, and is simply an important
local pathway, joining two ends of the town together, and opening up
the back land. It can serve other purposes as well. This regional
road, when it is built, a spur will come off it to feed Weston, and my
idea--I have the feeling that this spur will be the road from Locking,
past the Aerodrome, over the bridge. That would make a very good
way of approaching Weston. It is an open, uncluttered street, and
already quite a decent road. Let us say we come that way. We
arrive at a roundabout here, where we join the "B"artery. From there,
we want to go to the sea. We reckon to take them to the sea, to run
down the "B" artery, which will be a brand-new pathway, lined with
trees, and broad green strips on both sides, and which is in one
straight point to the sea, along the lines of Clevedon Road. It will
give a really impressive front door to Weston. People's first
impressions, after all, do count, and it should be that Weston is a
fine, noble and spacious town, and this will give that effect. It
is a long-term project. It involves moving the railway and widening
Clevedon Road, and we do not consider it to be an early priority.

Lastly, on traffic arteries : We accept the Bridgwater Road to the
Sea Front,/Beach Road and around Kewstoke Road is a most important
The

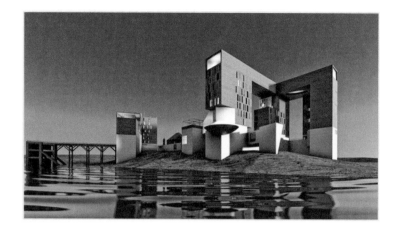

13 Designs for the 2007 Royal Institute of British Architects and Urban Splash competition to 'bring life back to Birnbeck Island and Pier', originally designed by Eugenius Birch and completed in 1866. Antonio Cardillo. AOC Architecture. FLACQ Architects.

road. After all, it is a sea road. We call that the "D" road. We

improve it around Birnbeck Island, straightening bends, widening when

necessary, and removing the toll, I hope. (Laughter and applause.)

At this point, whereit dives into Worle, and becomes congested, we

take a by-pass, avoiding Worle, and bring it straight out on the

Bristol Road, thereby freeing Worle of through traffic, and leaving

it the quiet, cosy village which it must remain.

Now, we come to the question of local traffic roads, the roads

which take people quickly about the town. Bus routes. There are

a larger number of these. The most important of them I call the

"Inner Ring", and it runs like this (indicating on plan). That road,

of course, is to some extent an existing road, in parts widened, in

parts new. It starts with Regent Street, which is widened and double-

tracked. It runs then along Alexandra Parade, and Alexandra Parade is

extended southwards to the new Station, and Regent street. The

"Inner Ring" runs southwards to the new Station, crosses the new "C"

artery, and carries straight on on the line Moorland Road, Quantock

Road to a new roundabout by the Sanatorium. It carries people and

quickly in their cars from the Station, down the lovely, wide Alexandra

Parade to the Pier. It also carries people southwards. It is also

the Station's main feeder, and links the Station with the new "C"

artery. It also has the effect of taking the load of north-south

traffic off the Sea Front. Grove (sic-Drove) Road does the same job

a little further inland, and, we hope, will continue to do so, from

the cricket ground to a roundabout on the new "C" artery. It feeds

the industrial area, the goods station, and on its present line it

crosses the new "A" artery, and is carried and widened in one area

straight through and up through the Woods to the Water Tower. The
Water Tower we would like turned into a tower from which you can look
at the view, and an observation tower, and a cafe, a place where people
could go to admire that magnificent view. The road contours down,
and joins the main road at the bottom, and provides a very good link
to Kewstoke. That will be a valuable local road. The rest of the
local roads are better shown on the larger scale. We have the "Inner
Ring," Regent Street widened and set back, and a roundabout at the
point where High Stree, Meadow Street, Union Street, and the rest of
them meet.The existing Alexandra Parade planted and improved, with
new frontages, swung slightly southwards straight to the Station.

At the other end, the Station looks straight into Ellenborough
Park, which is opened up by a simple process, so that from one end
you can walk to the sea in next to no time. From there, the road
cuts across the "C" artery, which exists, and so, by the roundabout,
to the Sanatorium. Because we have provided this artery we are enabled
to cut Walliscote Road. There was loud applause when we mentioned that
before. This is done for two reasons. We think Walliscote Road, as
a traffic road, is so close to the Sea Front that it duplicates the
it, and it tends to bring traffic into an area where we do not want
it. Secondly, it cuts xxx two parks in half, which is unfortunate.
If we can encourage nearly all south traffic to proceed on the "Inner
Ring" it will be possible, and, we think, desirable, for Walliscote
Road to be cut, and that will have the effect of converting this area
into a large precinct in which no roads lead anywhere, and, therefore,
no roads will lead anywhere. Therefore, it will be quiet and pleasing.
(Laughter). And similarly, of course, this southern residential area

will be islanded by main roads, and free from traffic, and suitable
for gradual re-development as a residential area.

Other local traffic roads : The old Locking Road. It has lost its
shape, so to speak. Its work is done by the new "A" artery, cutting
into The Boulevard. So that it need not be touched to any great
extent, but we have re-built its frontages along this last part, which
is obviously desirable, and brought it into the new Alexandra Parade
extension at the roundabout. We feel that Locking Road must be
accepted as a local/road, although we do not want it to be a traffic
artery, bringing in everyone from the outside road. Kewstoke Road
is improved throughout its whole length. Orchard Street is widened
to a double-tracked road, to provide a link between Alexandra Parade
and The Boulevard. This north-south road is very popular at the
moment, and it is not wide enough for its job. It will also act
as the eastern boundary of the shopping centre. So much for the
main traffic roads. There are others of minor importance, but I
have already been a long time.

Access roads : The last category of the three. The object there
is not to facilitate traffic, but discourage it. That is why we make
them into dead ends wherever we can. We give them wide pavements,
plant them with trees, and even cobbled services, If possible, I would
like to stop people from taking undesirable short cuts. The great
idea is to make them pleasant to walk in, rather than drive at 40 miles
an hour down.

The question of buses : There are two kinds of buses. There is the
local and the long-distance coach. I have already said we would like
to see the local buses restricted to local roads, and the big arteries

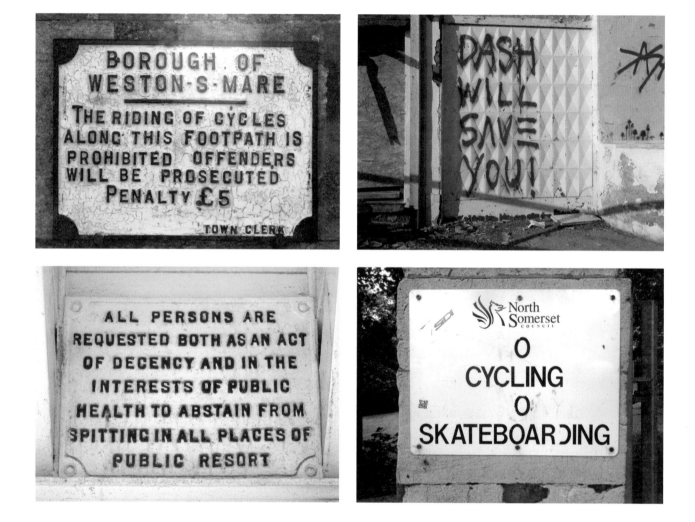

14 Weston-super-Mare reconnaissance, photographed by Stephen Hodge. Sign from footpath next to Uphill News on Old Church Road (March 2010). Sign from shelter overlooking miniature railway at the end of Marine Parade (August 2011). Graffiti near Anchor Head (April 2010). Sign from Grove Park gatepost on Grove Lane (August 2011).

as well, but not access roads. The last thing we want to do is to restrict the efficiency of the admirable bus service Weston has at the moment. We do not want to decrease its efficiency, and there may be exceptions to this rule. For instance, the centres of Worle and Uphill, although they do not rank as local traffic roads, should probably be served by buses direct. But you will never get an efficient bus service or road safety so long as you have buses nosing their way through crowds of shoppers. The buses have to go slow, and shoppers get occasionally bumped in the back. The thing is not efficient for anybody. We have planned our local traffic roads in such a way that nobody is more than 300 yards from a bus route. That being so, we reckon buses can be restricted to these local traffic roads. The present Bus Station on the Beach Road, we reckon, is not happily sited, but, of course, we recognise that it is a new building, and it cannot go tomorrow. In due course it will move, and we have provided her, a large brown blob, which represents a new Bus Station, and it is here better sited from every point-of-view, although we appreciate your comments and the comments of the Bus Company on this proposal that it should be on the new Alexandra Parade extension--an island site, suitable for turning the buses, and very suitable for quick inter-change between rail and road. That present wonderful site there could then be used for a large, tall building, more worthy of the view.

The question of long-distance buses and coaches. The queue of coaches up the Sea Front is not a very desirable arrangement. Long-distance coaches will eventually come down the new Clevedon Road, deposit their passéngers, and return to a park which we have provided, as

near as we can get them without taking very valuable land, and then,
later in the day or evening, will return to collect their loads and go
nome.

 Car Parks : This problem is not completely soluble, we do not
think. You cannot economically provide sufficient car park accom-
modation to take the full load of August Bank Holiday that will be
economic during the rest of the year. We have accepted that during
peak traffic periods some over-spill of cars on the Sands may be
necessary, but only at peak Bank Holidays. We have very largely
increased the area of car parks along the Front. I need n̶o̶t̶ go into
all of them. The main ones are : A new one at Grove Park, a very
big one in the centre of the shopping area, on the site of Palmer
Street, opening in all directionse-the Boulevard, High Street, Orchard
Street, Meadow Street--and a new one behind the Arcade site ; a new
one in the rather undeveloped area around Union Street ; a new one
behind the Town Hall, mostly for people visiting there or working in
the Town Hall (Laughter and applause) ; and a large one--I am so glad
that is so popular ! (laughter) ; and there was a big park along the
Station, and another big car park for your people arriving by road
down the new "C" artery. There is a very considerable area of parking
accommodation, which can handle over 1,000 cars in addition to the
present parks. We have tried wherever possible to put the parks on
back land, and not use valuable and conspicuous street frontage for
them. We reckon, wherever possible, street parks will be tucked
behind a screen of trees. They cannot be made attractive places,
particularly when empty. So much for traffic communications by road,
and the whole question of buses and cars.

The next heading is Industry, and to cope with that we must revert once more to Plan No. 2. The question of Weston industry is a very difficult one to deal with, because it depends on national policy, of which we have no more information than anybody else. At the moment, as is well known, Weston has one large industrial undertaking, outside the boundary, which employes a large number of people, who live in the town. Whether it will be national policy to encourage more industry to come to Weston or not is a matter of some doubt. There are arguments on both sides. Weston is a pleasure resort primarily, and not an industrial town. On the other hand, there is a lot to be said for decentralāztion of indystry from Bristol in various directions, and I think that we can expect that there will be some increase of light industry on the fringe of Weston. It is a thing we do not view with any alarm at all. It is a question of having it well-planned. We simply plan to extend the existing public utility area--the gas works, etc.--eastwards, which will be easily accessible to the "D" artery. Secondly, the industrial zone should go in another place ; and the third place could go in another place. Those three provide a pretty considerable area, and probably more than Weston will need, in which case we advocate strongly that one at a time should be developed. We do not want a couple of factories her, and a couple there, spoiling the land for agricultural purposes, and not really filling it for anyn need, either. We want one industrial zone filled at a time, well-planned, and as much care taken in its development, for a sprawl of factories is just as bad as a sprawl of houses.

It is suggested that some provision should be made for the small
man who cannot afford to build a factory, but wants space where he
could operate a small business in industry--builders' yard, etc.--and
it has been suggested that a small trading ××××× estate should be
laid out for his benefit in a convenient position that could be
developed soon, for the benefit of ex-Servicemen who want to start
up in these forms of business. The first site which is readily
available for that purpose, owing to existing roads is here (indicat-
ing). We reckon that would do quite well, provided it is carefully
laid out. Industry is rather a big question mark.

Business and Trade : The question of shops. The present distrib-
ution of shops in Weston is, on the whole, not satisfactory, as far as
their position is concerned. There is, of course, considerable
ribboning of shops down Baker Street, Milton Road, etc., but it is not
quite as serious as in many places. On the whole, we accept the
present position as shopping centres almost entirely. Let us take
the main shopping centre first, and refer to Plan No. 3. At the
moment shops are concentrated in this area, and, of course, they must
stay there. The question of lay-out, especially the centre, is
particularly important, I think, in a seaside resort, because it is
what people want to do on a wet day--go shopping. At the moment,
Weston's shops are not particularly attractive from that point-of-
view. Let us see what we can do about it. To start with, there are
certain parts of that area which have got to be re-built. Bomb
damage here, dilapidated and partly-bombed area there ; another
bombed area there ; another dilapidated and bombed area there. When
we re-build we might as well re-build an affair which will be really

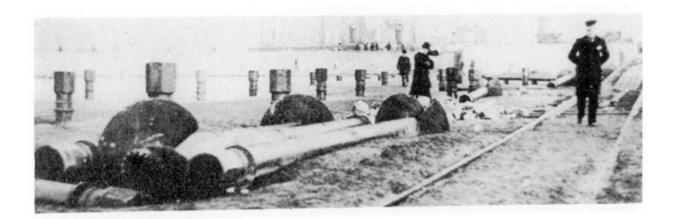

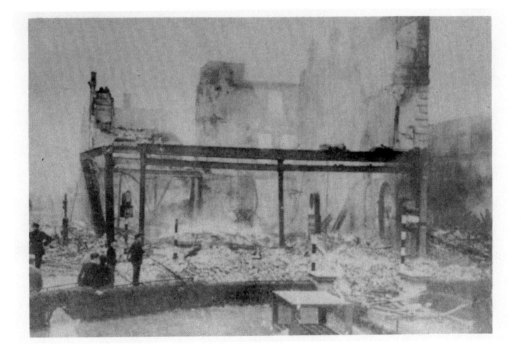

15 Images of construction and destruction, sourced from Bryan J. H. Brown and John Loosley's *The Book of Weston-super-Mare: The Story of the Town's Past,* published by Barracuda Books Limited (1979), bought from Sterling Books on Locking Road (December 2011). Foundation piles for Grand Pier (1903). Bomb damage in the town centre (June 1942).

attractive. We would like to see shopping areas built, not in the form of arcades where you walk in glass on each side, but in the sense that you walk along a pavement with shelter over your head, and, apart from that, the great thing is to be able to shop in the rain without getting wet. Also, of course, it is desirable not to get run over. So what we have done is to island the main shopping centre by big roads which will take all through traffic, preventing it infiltrating into the shopping area. There is the new Regent Street, a widened Orchard Street, and the Sea Front. Inside that rectangle no cars should go, unless they want to go shopping, and if they want to go shopping they wont be able to park. We have provided a large park in two places, and, with that provision, we reckon parking in High Street, Meadow Street, and any other area there, should be prohibited. (Applause.)In that case, it will be possible for High Street to become a two-way street, which is obviously desirable for a main shopping street. The question of Meadow Street : At first sight you would say it is essential that it should be widened. The danger is that you merely attract more traffic into it, and find yourself exactly where you xxxxx started. It is arguable that it would be better to deter traffic from entering Meadow Street at all, and keep it narrow, and provide a fast, adequate traffic road along-side--which is done--and with all that we reckon that Meadow Street need not be greatly widened. At the southern end the frontages will need to be re-built, and some straightening is desirable. If any-thing, we like to see business streets widened, and, in a street of one-way working, from west to east. This plan only works on the assumption that it is one-way, from west to east. We do not want

people who come in this way to be allowed to have motorists threading their way through. If, a motorist sees a large sign, "No entry," he will stick to the road designed for him, and he will stick to the main shopping centre.

We show on the Arcade site a small new square which we want to see developed. This is not our own idea. It was put up to us. We take no credit for it. It should be developed as a small amusement centre- a couple of cinemas, cafes, curio shops, and a quiet square, with the car park immediately behind it, so that traffic would not clutter it. Brightly lit at night, and, generally, a feature for a wet day.

Here, we visualise the above sites : Meadow Street and Alexandra Parade, with shops opening out of it, single-storey, small, lock-up shops, opening on to it on either side. No vehicles, plenty of space for shoppers to walk about and gossip, and pass the time of the day. (Laughter).---In general, our central shopping area consists of a square, bounded by traffic roads, and in the centre of it a large car park, to prevent the parking of cars on the main streets. Certain shops exist south of Regent Street, and will continue to do so, but we only want to see the very best. We do not want to see the pin-table saloon, an amusement park, and it will be possible for the Council to prevent undesirable businesses in the civic centre. Alx though Just as we have tried as far as possible to concentrate shops in the central shopping area, although we agree the present Baker Street shops should remain where they are, we do not want ribboning of shops down this street, and we want to restrict the shops in this area, and let the area gradually revert to residential use as it is re-built, because it will all be re-built. We envisage this area

primarily as residential. In the suburbs we do the same. They
consist of small red blobs. In nearly every case these are existing
groups of shops, which are sensibly situated, and where any new shops
should go. We regard it as essential that new shops should only be
allowed into these particular positions, and nowhere else. The
positions are : Ashcombe, a few shops there already, and they are
obviously desirable to serve that area between the center of the town
and Ashcombe Park. Milton must have its shopping centre on the
Milton Road. Milton Road is not treated as a traffic road, and we
would do eveything to discourage through traffic along Milton Road,
which it is not capable of taking. Worle must have its central group
of shops, combined with its other central amenities--cinema, health
centre, etc. The new Worle Moor must have its shopping centre.
There are two suburban shopping groups : Whitecross Road, which we
should retain, and Moorland Road, which we would also retain. Any
shops desiring to set up in that area would have to go into one of
these areas, if they can get one. Bournville will have its own group
of shops as part of the new community being started there. Uphill
must have its own shops, a village unit, and Bleadon Hill, which, we
hope, will turn into a village one day, will have its shops at its
geographical centre.

Just as there is a main shopping centre and suburbna shopping
centres, each a miniature version of the main one, so there is a
central and suburban civic centres, too.

The question of a new Town Hall : It has been represented to us
that it would be best to scrap the old Town Hall and start again on
Alexandra Parade. We are inclined to think that that expensive

project is not justified, because Weston must spend its money as far
as possible on the things which people come to Weston for, and they
do not come to Weston primarily to look at the Town Hall. (Applause.)
So we retain the old Town Hall--(laughter)--which is a friendly old
building, but we appreciate that something must be done about the
area beside it and behind it , and that it, itself, is inadequate
for its purpose, and needs enlarging. We propose that a new Carlton
Street should be taken on the line of the present at its western end,
so that you will achieve a dignified appearance and see clearly through
the trees Steep Holm Island at the other end. It would have an
avenue of trees, a wide pedestrian pathway, a green narrow strip. It
is not designed for traffic, and does not need any now, because
Walliscote Road, as you will remember, is washed out. This can be
counted upon to remain a wide, dignified street, and down it we would
put the Civic buildings which Weston so badly needs, starting with
an extension of the Town Hall, and, possibly, a centre for various
post-war organisations, and here a new health centre, etc. This
would form the southern boundary to the Civic centre of Weston. Here,
a car park, to serve the Town Hall area, and a new Union Street, on a
different line, connecting the area with the big roundabout here. The
frontages to the new Union Street we have re-built on both sides with
other public buildings. We imagine this will come in useful pretty
soon, because the site is cleared. Richmond Street (sic--St. James
St) we do not like. We know people will say Richmond Street is
decayed and should be abolished, but it has its charm, and in this
Plan it is not touched, and it has its cosy character, which we like.
Oxford Street is re-built ; its blitzed buildings are ripe for recon-

DEATH OF MR. Hans. F. PRICE.

An old and valued resident

Although general regret will be associated with the announcement
of the death of Mr. Hans Fowler Price of this town - the sad event
occurring at his residence, Bourn, Trewartha-Park, on Wednesday
last - very little surprise will be associated with the intimation, for
three weeks since, in recording the fact that he had been seized with
grave illness, we stated that there was practically no hope of
recovery. The loss, however, will be regarded as none the less
severe, for Mr. Price, as professional and public man, and as
private resident, was, and had been for over half a century, very
closely associated with the general welfare of the town. Head of
the firm of Hans F. Price and Jane, he was the doyen of the local
architectural profession, and in that relationship as well as by
his gifts as a business man, he had taken an important part in the
development of modern Weston. Possessing a practically unerring
judgement, and such intimate and long-continued experience of
the town, he might well have been locally regarded as something
in the light of Chalcas of the Iliad:-

> That sacred seer, whose comprehensive view,
> The past, the present and the future knew.

This value, as well as his sterling attributes, were, therefore,
everywhere recognised, and thus his loss is sincerely mourned in
a dual sense. One of the most remarkable features associated
with Hans Fowler Price was his remarkable fund of vitality.
Although he had exceeded the alloted span of years, andpossessed
great wealth, any idea of retirement would have been absolutely
repugnant to him - and thus it came about that up to the day of
his last illness attacking him he had been as busily engaged in
professional and other work as ever. And this activity was as
fully marked mentally as it was physically. Although his hand
might be still it was apparent to all who knew him well that his
mind was ever actively working. Not that he was a dreamer,
however. As a matter of fact, he was the direct antithesis
of anything suggesting it, and if he dreamt at all it was of
action. So far as we are aware, he had but one real pronounced
recreation,and that was of too strenuous a character to be so
regarded by the ordinary busy man - chess.

16 First page of the draft *Weston Mercury* obituary for Hans Fowler Price (November 1912),
found in the North Somerset Studies Library on Boulevard (May 2010).

struction.

Along the Front are a series of tall buildings, which we visualise as hotels or blocks of flats--probably, mostly hotels. They are at right angles to the sea, so that the maximum number of windows get a glimpse of the sea which can be contrived. We visualise 80ft. and 60ft. high buildings, which is a new thing for Weston. It is absured that the Grand Atlantic should stand up in isolation. It is not such a worthy building. (Laughter.) Tall buildings will arise in these areas. I do not say they should not go all the way. We do not want much of the Sea Front demolished, because we do not want to startle people unduly. It is rather, at present, like a cricket team eleven, with one or/two good batsmen at the top, and an undistingui-shed tail. We want all good scorers all the way. There is a big building, a large hotel, built on the end of the putting green--a tall building sticking right over the Marine Parade--tall enough to hide the Sanatorium. We feel the Sanatorium should not be as con-spicuous as it is at the moment, and this building would not/affect have the effect of hiding it from the north, without obscuring its views.

Other community buildings : We show here, on the sea-ward end of Ellenborough Park noble buildings facing eachother across this pathway leading from the Station. You will remember that it is now possible to walk from the Station through Ellenborough Park to the Sea, with this new development on either side, and here is the site for the Conference Hall, a restaurant, and general purposes, suitable for national conferences which, we believe, Weston badly requires. (Appls.) There is no end to the other public buildings which at some time or

other can occupy this magnificent new site. A new theatre is there,
again, facing the Winter Gardens, in a convenient position, close to
the little museum centre, so that the whole area becomes brightly lit,
and a gay place, where crowds can congeegate, and there is plenty of
room for people to move. The concert pavilion at Grove Park we
would like to see re-built, but we have provided for a small square
there, with the blitzed church buildings on one side, with the pavilion
on the other, and a portico looking straght down High Street, so that
people would be able to find their way there is the evening. I do
not know if there are any other mysterious markings on the map which
you need to have identified. You can ask me afterwards. I have
nearly finished, anyhow ; I have very little voice left.

I think I should, before ending, explain that we do not intend to
do all this next year. (Laughter). Roughly, we have envisaged this
central re-development in three main phases. The first phase would
occupy roughly the period, 1950-1960. We do not reckon to make any
start in the central areas until 1950, because housing will take
priority. In that ten years the most important jobs will be done.
We have marked dark brown on the map the first priority jobs. They
are all the jobs which can be done, because the sites have been cleared
by bomb damage and some considerable extent of the areas are dilap-
idated and urgently need reconstruction. The first thing is the
swinging of The Boulevard to the north, along the line of West Street
to the Sea, and re-building the frontages on both sides. That can be
done without any difficulty as soon as one is allowed to do it.
Reconstruction of the Arcade site : That can be done. The land is
practically cleared, except for the terraces. That can be done at

an early date, and provide the little square we mentioned. The re-
development of the southern end of Meadow Street can be done easily.
A triangular block in this area is to some extent dilapidated, and there
is bomb damage there, too. Again, these years : The Union Street
re-development can take place soon, because of bomb damage in some
places ; and that part of the Sea Front ; and, again, the Union Street
project, which we put up as a first priority. That is all about the
first priorities go. Second priority : And for that we take the
decade, 1960-70, and are marked pale brown. Those are dependent
on the railway doing their part. None of these pale brown jobs, or
few of them, can be carried out until the loop has been flattened,
and the new Station built. Then, it will be possible to develop
this area, with its flats and houses, and build a new Bus Station,
to complete the widening of Regent Street, which is not immediately
urgent, but which should be done then by re-building its northern
frontages, and complete the re-development of that area between High
Street and the Sea. To that period we would put the widening of
Orchard Street, which is highly desirable, but not immediately urgent.
Its frontages will be re-built. There is one thing I did not mention
among the first priorities--the Conference Hall, which, I think, is
urgent, and can, obviously, be built as soon as possible. Second
priorities are mainly contingent on the railway,

The last priority : Ten years,from 1970-1980 I think we have got
to now. (Laughter). The main jobs there. By then, we reckon
the time has come for the construction of the bib boulevard which we
call the "C" artery--a new, widened Clevedon Road, with big buildings,
and widened, and giving a sense of grandeur, and the sense of leading

TO NEW HORIZONS

A quarter of a mile high, skyscrapers tower, with convenient rest and recreation facilities for all. On many of the buildings are landing decks for helicopters and auto-gyros. Rich in sunshine is city of 1960. Fresh air. Fine green parkways. Recreational and civic centres. Modern and efficient city planning. Breath-taking architecture. Each city block a complete unit in itself. Here is an important intersection in the great metropolis of 1960. Elevated sidewalks give a new measure of safety and convenience to pedestrians. They actually double the available width for traffic in the street. And so, we see some suggestion of the things to come. A world which, far from being finished, is hardly yet begun. A world with a future in which all of us are tremendously interested, because that is where we are going to spend the rest of our lives. In a future which can be whatever we propose to make it.

True, each of us may have different ideas as to what that future will be, but every forward outlook reminds us that all the highways of all research and all communication, all the activities of science, lead us onward to better methods of doing things. With new opportunity for employment, and better ways of living, as we go on, determined to unfold the constantly greater possibilities of the world of tomorrow. As we move more and more rapidly forward, penetrating new horizons in the spirit of individual enterprise, in the great American way.

17 Voiceover from *To New Horizons*, a documentation of the 'Futurama' exhibit from General Motors' *Highways and Horizons* pavilion at the 1939–40 New York World's Fair, a Jam Handy picture (1940).

you straight to the Sea. Contingent on that re-development would be
the reconstruction of certain areas on both sides, opening up Ellen-
borough Park by clearing the crossing at the eastern end, the recon-
struction of these blocks here, and, in general, the completion of this
development in this area. Also, in that third priority comes the
closing of Walliscote Road at the two Parks, and the crisis in this
phase includes the new "Inner Ring" to the Station, via Clevedon Road.
A third priority is the replacement of one block of buildings which at
present exists by the large green space with a block of flats in
future.

I think that gives you a rough picture of how we visualise the
phasing of the job. I hope it does help to bring out the point that
we are not proposing to do anything violent at all. It is simply
that these things have to be done, and Weston has to be made a really
lovely place, or it will simply go downhill. One cannot, in these
things, stand still.

By way of peroration, I do not know if I ought to mention the
question of financing the job. I think there are two ways of looking
at it. The first is that these things pay ; a great many ultimately
pay. They pay in ways that are extremely difficult to compute. If
you build a new road, however dilapidated it may be, you increase this
road enormously, and the town benefits. There is the more abstruse
point that everything you do brings more people to Weston, and
increases Weston's income accordingly. It is impossible to say how
many people are brought to Weston by the fact that you have made a
magnificentn ne Alexandra Parade. The chances are if people are
choosing a place to go for holiday they will be influenced by these

things. To some extent, improvements pay. At the first, it is
expensive. The capital outlay is enormous, and cannot possibly be
faced by the local authority. There is a new Bill on the stocks
dealing with that problem. Compensation, which, hitherto, has
prevented local authorities from doing these things, is now to be
tackled on a national basis. It is fine from the point-of-view
of local authorities. Whether it is so good from the point-of-view
of the property-owner I do not know. There is no doubt it will be
possible to finance all these things. Compensation will be tackled,
and a large grant will be forthcoming from the Government to enable
towns to re-build their premises. It has always been easy to build
houses in the country. Extending towns has always paid, but hitherto
it has not paid local authorities to do anything about the centres.
This Bill is to enable the local authorities to carry out central
redonstruction. Far from this scheme being wild and crazily
ambitious,if anything, should it be adopted, it may be thrown back
because it is not sufficiently bold. I think far more like that than
anything else. For better or for worse, the authorities are
frightfully keen on this re-development of the centres, the decaying
centres, of old towns, and it is the most important aspect of our
plans.

I mentioned that the old, two-engin bomber was flying along on its
one engine. The aircraft is now circling over the aerodrome, pre-
paring to come down. It hasvvery little petrol left, so with your
8.50 permission I will now come in to land. (Applause.)
p.m.
The Mayor : I feel you have had a most interesting address, and
after what Mr. Lionel Brett has said I feel sure you will have many

18 Weston-super-Mare reconnaissance, photographed by Stephen Hodge and Cathy Turner. Telephone hanging from the former control tower on Weston Airfield (April 2010). Road sign in Milton Road Cemetery (April 2010).

questions ready. I will be glad, therefore, if in a few moments
those desirous of speaking would come to the front and speak through
the microphone on the floor. By this means, everyone will hear the
question and the answer, and if the speakers will give their names
before speaking I am sure the Press will be very grateful. I should
like to ask Councillor Procter, Chairman of the Works and General
Purposes Committee, to come on the platform and say a few words.

Councillor T. W. R. Procter : I readily accept this opportunity of
saying a few words on this, which I consider to be a most historic
occasion in this town. The speaker, when introducing his subject,
stated that this type of meeting was an innovation in the annals of
planning. Normally, the Council prepared the Plan, and you received
it on a plate, whether you liked it or not. In Weston, this Plan
is mainly the outcome of your ideas. It is the completion of what
the National Press of the country and the local Press was good enough
to term, "An experiment in democracy." We were overwhelmed with the
ideas and suggestions which came from every Association and nearly
every branch of organisations in the town ; and, indeed, they have been
found extremely useful to the Planners, the result of which you have
seen to-day. In last week's Press this was termed, "The Master Plan."
I suggest to you it is a masterly plan, well conceived, and put over
in a very masterly way. As you have been informed, it is just a
broad outline, and, I hope, will form the basis for the future progress
of this town. Councils may come and Councils may go, but it is up to
you to see that your Plan is implemented. Mr. Brett has already
mentioned that it is very difficult at this juncture to make obser-
vations on the question of finance, and until we know the regulations

or conditions in the new Town and Country Planning Bill it will be impossible for anyone to make even a wild estimate. My purpose in being up here is to endeavour to get you to come along and ask questions. There is a microphone on this side of the platform. There is no need to be nervous. We would like as many questions as possible, and I want to stress this : Please let them be questions, and not speeches ; and, also, please confine your questions entirely to the Plan and the remarks you have heard this evening. I feel sure, if you do that, we shall all be pleased, and, moreover, your short statement will enable either Mr. Brett, the Town Clerk or myself to become an informal "Brains Trust", and try to answer what you want to know. For those persons who might not have, I was going to say the courage or the liking for the flame or burst of publicity to come to the front, we have arranged that around the hall there are stewards, who have pencils and paper, and you can write your questions down. Please put your name on the paper, and then it can be passed up, and thenread out, and, if possible, answered. We are not going to hedge if we can help it. We want criticism. We hope it will be constructive. I was at a lecture the other evening, and when the lecturer had completed his paper he found great difficulty in obtaining the first question. He said it likened him to getting the first kiss out of the girl--the first was rather difficult to get, but the others came very easily. I am only hoping the questions to-night will come easily, and we gladly invite the first man or women to come along on the right of the stage--your left.

8.55 p.m. <u>Mr. Geoffrey Knowles</u> : I was going to ask that I might not have any publicity, and in the first place I shall not be carrying out what

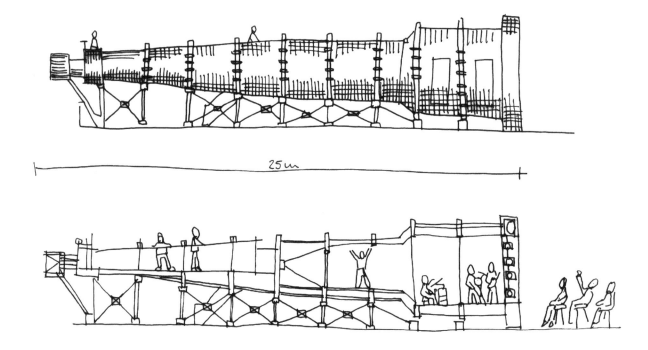

25 m

19 Raumlaborberlin, Sketch for unrealised commission for *Wonders of Weston*, 2010.

Councillor Procter asked us to do, and only ask questions. I believe
those at this meeting are greatly indebted to the Mayor and Council
for having called this meeting. Secondly, I think I may be able to
fill up what Councillor Procter has said on the matter of the Plan
being a Masterly Plan by saying I think it is a masterpiece. The
only question I wish to raise in tabloid form is : Will there be
another opportunity when we have digested this very heavy meal because
of its size to make representations on this Plan before it is printed
in book form ? Because I submit, with respect, that we do rquire
some opportunity to consider the splendid way in which this Plan has
been put forward by Mr. Williams-Ellis and his Partner. We regret
his absence, but I am certain everybody here is delighted at what we
have received from Mr. Brett. I would ask Mr. Brett : Is there any
means to build on the lawn ? Secondly, could an alternative to the
Railway Station be carried out, and still preserve the Rugby Ground ?
I wont be selfish in the use of the microphone, and I wont ask any
more. If the first question is answered then there will not be any
need to answer the other.

Mr. Brett : I would thank the last speaker for his remarks. To
start with, in general, I would like to endorse what Councillor
Procter has said about the assistance we have had from the various
local bodies, associations, individuals, who have sent in their
ideas. Many of them will, of course, recognise their ideas in what
was on the screen this evening, and I think it is the biggest tribute
one could pay to them that many that have actually got into the Plan,
as far as it goes. Equally, we have had great assistance from the
Regional and local bodies outside the town, and, altogether, we could

INDEX

84

20 Page from the 1991 Nintendo version of the *SimCity* manual (originally developed in 1989 by Maxis Software).

not have done this job without the assistance both without and
especially from within. That brings me to the point : the first
question asked by the speaker, and it is whether the public will have
the opportunity of thinking it over and submitting their views after
to-night. A chance of that ? The answer is, of course, is that is
the whole point of this meeting. I came down to-day to find out what
you think, and we do not expect you to get up and say here and now,
all of you. These things do need some thinking over, and we are
going to mark time on the Plan until we have got in any observations
we have had from this meeting, and those observations which will
help us to improve the Plan will go into it. The answer is that
most certainly nothing will be done XXXXXXXXXXX that is final.
There will be no book printed or final drawings made until we have had
the full repercussions from this meeting, sorted/out, and made the
best of them. The answer to the other question is that there is no
intention of building on the Beach Lawns, with the exception of the
hotel at he south end, which was built on the putting green, I think.
The Beach Lawns remain as they are, except that it would be nice to
have them planted with trees, if any trees could be induced to grow
there. It is not necessary to remove the Rugby Ground merely because
one is flattening the loop. The loop can be flattened over the
existing allotment areas without seriously cutting into the Rugby
Ground, but you will be left with the Goods Station cutting into the
heart of the town. The point to decide is whether you out the Rugby
Ground first, or whether you put first the improvement in amenities
which would result from getting rid of the old Railway Station. If
you pulled down the hoardings and dug them out you have a site for

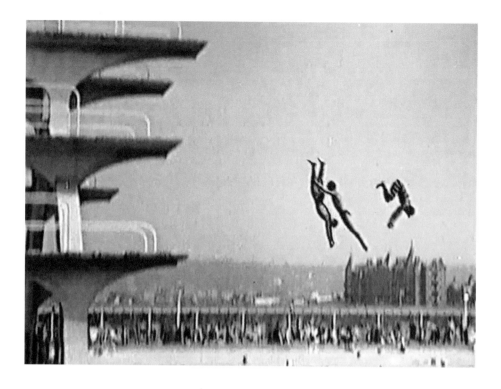

21 Stills from *Down Somerset Way*, produced and directed by Harold Baim,
and photographed in Eastmancolor by Alfred Burger (1957).

re-development in a magnificent way. Certainly, it is not essential

to remove the Rugby Ground. None of these things are essential.

They are things that can be done if you like them. (Applause.)

Mr. A. C. Jones : The speaker has told us the first year plan,

when mentioning communications, and I noticed road and rail were very

fully dealt with, but there was the omission of the future aerodrome

to explain. We are moving with the times--jet planes--and it is in

the fashion at the present time. It is easiet to fly to Cardiff

than go by G.W.R. Secondly, there is sea traffic coming from Cardiff.

If there going to be any extension or new works regarding either of

the Piers ? Presumably, the Old Pier is more suitable for berthing

ships. It could be lenghtened, and I would like a little more infor-

mation on these two points. (Applause.)

Mr. Brett : I talked in a big way about road and rail, and never
 others. Neither of
mentioned axthingxof the other two are in the terms of reference.

The aerodrome is not inside the Borough, and the Borough has no

control over it under the new Civil Aviation Bill. It is a national

matter, and the local authroity has very little control. All we

could do was to provide quick means of communication from the town,

which we put by the "B" artery, running into "C" artery. We realise

the importance to Weston of the Airport, and we hope to goodness the

Airport will stay there, but that is all we can do about it, apart

from giving it a good link with the town. Sea communications I : It
 not
is/really any business of ours whether the Old Pier should be improved

and whether the service with Cardiff should be increased. Again, I

imagine it to be desirable, but we were concerned with the town Plan,

and we reckoned that neither of these things really came within our

terms of reference. (Applause.)

Mr. Maxwell : I am afraid I cannot criticise the Plan in any way. It is far too much for my capabilities. There is one thing I did think good when the speaker was explaining it, and that was that nobody could cope with the tides of Weston. The Esplanade has been discussed, as far as the extension to Brean Down. Had that been done, I think Weston would have had the tide in all the time. The water would be deep enough, I understand, to accommodate ships of some considerable size unloading.

Mr. Brett : The extension of the Esplanade to Brean Down is a project which we have been asked to comment upon. I did not mention it this evening, because it was not partof our Plan. We considered it was too big a job. There are limited resources. One has to get a Government grant to do any of them. I do not know whetehr a Government grant would be forthcoming for that project. What the Government wants to see re-developed is the decayed central areas of towns. They wont pay money for a project for any extension to Brean Down. Again, we were not keen on including Brean Down. We like to leave it in its present isolation, as a bird sanctuary, to which only adventurers can go. (Applause.) The Esplanade in Weston is just about as long as it ought to be, we think. You can only just see from end to end now. Beyond that would be to create a Blackpool waste of space. If anything, I think it is too spacious, and, quite frankly, with the sacrifice of the Golf Course, we came to the conclusion there were better ways of spending our moneythan on an obviously expensive job, which would involve bridging that tidal river. (Applause.)

Mr. J. S. Leaver : As Chairman of the Chamber of Trade Sub-Committee

that put a report in I should like to ask if it is possible, without
going to the trouble and expense of print, for us to have a reprint
of Mr. Brett's speech to consider ? Perhaps the Press would co-
operate with the Council, so that we could re-consider the very wonder-
ful speech that we have had to-night. May I be permitted, on behalf
of a Committee of Traders who spent some time on this, congratulate
the Council and the Planners on what we have heard. Personally,
I would like to hear a lot more of how Mr. Brett would develop the
XXXXXXXXXXXXXXXXXXX Arcade site.

Mr. Brett : As regards the first point. As far as I am concerned,
my remarks were mostly straight out of my head, so they wont read
very well. If the Press can reproduce them in an intelligent form
I am all for them being used as widely as possible. The XXXXXXXXXxx Arcade
site
XXXXXXXXX : It is difficult to talk about these things without
drawing pictures. The main idea is to turn it into a small-----I
think the best thing to do is to have the slide back. It would be
entered from the south, from Regent Street, between two new blocks
of shops and offices, and would be a long square, with the central
green area in the middle, with trees, a little entrance, a car park,
and small shops, cafes, open-air tables, a cinema here, and another
cinema there. They are so placed that traffic can get at them without
coming into the square itself. They cut xh through from High Street.
That is as far as we have gone, except we want it to be brilliantly
lit at night, full of life and gaiety. (Applause.)

Mr. H. W. Haydon : Mr. Mayor. In view of Councillor Procter's
remarks, on a point of order, may I have your permission to submit a
resolution to this meeting relative to the whole subject, ask for it

to be seconded, and put to the meeting ? The resolution I hold in my hand at the present moment.

Councillor Procter : Will you pass your resolution up, please ? I am going to read this resolution. First, I want to say it is entirely impossible for us to take a series of resolutions. (Hear, hear.) You will, of course, appreciate we do value any comment or criticism, but if we allow it for one we must allow it for all, and I doubt if we should get out of this room before another hour or so. I propose to give publicity to this resolution, although Mr. Haydon has already referred to two of the items which appear on it, and I suggest to Mr. Haydon that he might put the wording of this resolution--the third portion ofnit--in the shape of a question, and we will then endeavour to give him satisfaction. The resolution, as typed, is this : That this meeting of Citizens of Weston-super-Mare assembled at the King's Hall having heard the an exposition of the post-War plans of the Council deplores (a), that no garden house-planning scheme is included in the proposals, such as would afford relief to homeless residents and commensurate with the amenities suitable to a seaside resort, (b) the absence inxkken of any reference to the Brean Down Scheme as placed before the Council by the Rate-payers' Association sometime ago, together with the originator, and (c), that no mention, again, is made of the suggested all-year-round cross-Channel ferry between Weston and Cardiff. It therefore calls upon the Council to takeimmediate steps to include all these three suggestions with a view to the same being carried out as early as possible. Mr. Brett has already m answered a question in relation to the Brean Down Scheme, and also made reference to the question of

22 Tim Etchells, 'Winter Piece', 2010, commissioned as part of *Wonders of Weston*, photographed by Jamie Woodley (November 2010).

the cross-Channel ferry. Therefore, Mr. Haydon, if you could phrase
this in the form of a question we will endeavour to answer it.
(Applause.)

Mr. Haydon : My grateful thanks for having that resolution read
out. The question I would like to put is this : Does Mr. Brett, as
a part of his Planning Scheme, think that the cross-Channel suggestion
or ferry service all-the-year-round would be a very valuable asset to
Weston, and that it should be included in a future scheme ; and,
whether, in his opinion, it would enhance the town as a seaside resort,
placing it far greater on the map than it is at the present time, and
 far
bring/more visitors than could ever be done otherwise?

Mr. Brett : The answer to that is, it sounds a jolly good idea,
but it is nothing to do with the Town Plan. (Hear, hear.) A
Planning Scheme is a definite document, drawn on xxxx pre-determined
lines, and there is no provision for including in it any such things
as cross-Channel services. The question of garden homes is put in
the form of a question that I need not deal with at the moment.

Councillor Procter : We can deal with that quite simply, inasmuch
as there is no power in the hands of local government to provide
--in Weston, at any rate--to provide homes for destitute or poverty-
stricken people. However desirable it may be, we do not possess that
power, and I am afraid we cannot do anything at the moment.

Mr. R. V. Rowe : My knees are knocking, but my heart is sound.
(Laughter). He proposes to cut off the Sanatorium from the view
from the Sea Front. I was very sorry to hear that. (Applause.)
I think any town that has such pull that it can have a Sanatorium
placed in it should be proud of it, and, so far from hiding it, should

advertise it. (Applause.) Moreover, I would like to ask this question of the Planner. I do not think the Sanatoium would like to be shut off like a leper. (Applause.)

Mr. Brett : I want to congratulate the last speaker on a very able political speech. We were considering that as a work of architecture. If the sense of the meeting that you do not want to build and mask the Sanatorium then you wont have it, of course. (Applause.) It is perfectly true that it will hide the Sanatorium in that direction. It is actually due north from the Sanatorium, so there is no question of taking any the sun away. As a piece of architecture, the Sanatorium is not inspiring. We were looking at it entirely from that point-of-view, and there was no reflection on the Sanatorium, or those inside it. I rather gather from the meeting that you do not want a building between it and the rest of the town, and, if that is the case, you wont have it. (Applause.)

Mr. Powell : I would like to ask three questions. First, car parks. In view of the fact that there is a chronic shortage of space would not a multi-storey car park help ? Secondly, as we are likely to have a better time, with shorter working hours, could we possibly have another Swimming Pool ? Thirdly, as we have vast power of materils available, is it fair to state where the money is coming from, and are we to allow this to hold up Town Planning Schemes? (Applause.)

Mr. Brett : The question of car parks. We did, certainly, consider the provision of multi-storey car parks. We decided they are not economic, except in a big sity, where they would be used all-the-year-round to capasity. In a place like Weston, where the traffic

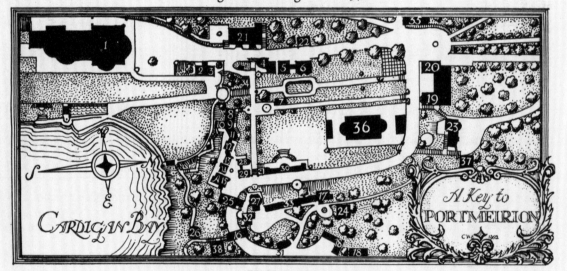

Diagram of Village as in 1972

A Key to PORTMEIRION

CARDIGAN BAY

DIAGRAM KEY

1. Main Hotel	11. Government House	19. The Ship Shop	29. Battery Stores
2. Anchor	12. Campanile	20. Salutation Restaurant	30. Colonnade
3. Fountain	13. Priors Lodging	21. Hercules Hall	31. Toll Booth
4. Angel	14. Battery	22. Angel Antiques	32. The Belvedere
4a. Golden Eagle	15. Toll House	23. Telfords Tower	33. Chantry Row
5. Neptune	15a. Pilot House	24. Villa Winch	34. The Gazebo
6. Trinity House	15b. The Peacock	25. Bridge House	35. Games Room
7. Mermaid (Staff)	16. Gate House	26. Belvedere	36. Piazza
8. Royal Dolphin	17. Chantry	27. Pantheon	37. Unicorn
9. Dolphin	18. The Lodge (Staff)	28. Apothecary	38. Lion
10. Watch House			

23 Images of the caves at Uphill (date unknown), sourced from Bryan J. H. Brown and John Loosley's *The Book of Weston-super-Mare: The Story of the Town's Past*, published by Barracuda Books Limited (1979), bought from Sterling Books on Locking Road (December 2011).
24 Portmeirion map (1972) by Williams-Ellis from *Portmeirion: The Place and its Meaning,* published by Portmeirion Limited (1963, revised 1973), given to Stephen Hodge by Phil Smith (October 2010).

problem is seasonal, they do not pay. They are extremely expensive.
Much as we would like them, and they make the Planner's problem
easier, we decided we must keep them out. The question of another
Swimming Pool. We have allowed for a Pool just south of Ellenborough
Park--a couple of blitzed houses there--and a new Baths behind. We
noticed that was among the many proposals put up to us, and we have
incorporated it. I think I have dealt with money. We really cannot
go further into economics at the moment. (Applause.)

Mr. Graddon : You made one reference to a national Conference Hall
and to other public buildings. I would like to ask : Would it not
be advisable and of some importance to place specifically on that your
Plan the construction of a Community Centre on the lines indicated
by the Minister of Education, with all these halls, an theatre, and
workshops, etc, for the youth of the town, and for the social life of
the town generally in its local aspect ? (Hear, hear.)

Mr. Brett : I think that was an excellent suggestion. We have
left several sites in the Civic Centre pretty indeterminate. I said
there were other sites developed for public buildings, and the only
point, I thin, is the kind of building. The suggestion would require
a considerable amount of open space around it, in which case we have
made no provision in the central area for such a building. Open
spaces in the central area are at a premium. It would mean going
into the public parks, and it is a thing which needs further consid-
eration. Community centres, of course, will be provided, and it is
certainly included in our Report at the main centres of population--
Bournville, Worle, Uphill--on a local smaller basis, but the point that
there should be at the centre a group of buildings designed primarily

for the young people of Weston is certainly a point which wants con-
sideration, and if it is the sense of the meeting that such a centre
should be provided we will get it in. (Applause.)

Mr. J. B. Smith : I wish to approach this subject of the Recreation
Ground with a proposition. I think the loss of the Recreation Ground,
 at present,
as it is XXXXXXXXXXXXpXXXXXXX would be a very bad one for the town,
 every
as it is in a central position, and is used generally by other sports
organisations in the town. There is, the Planner has told us, a
large tract to be used, possibly, for industrial purposes to the east
of the present Recreation Ground. While I do not disagree with
you that a goods yard is necessary, and the position he has chosen
would be suitable, would it be possible to use this tract he has
mentioned for the industrial undertaking for a new Recreation Ground ?
It is pretty centrally situated, and, I think, would fulfil the
majority of requirements for a new Recreation Ground. My second
question is : On the question of the Kewstoke toll road. He has
said he wishes it to be widened to form it into a presentable carriage-
way. Does he not think that in these circumstances he would disturb
rather seriously the rural setting in which it now is ? (Applause.)

Mr. Brett : I think it would be a good thing if we had the general
Plan permanently here. We shall certainly get references to it.
(Map No. 2 screened.) It has been suggested the Recreation Ground,
insteadoof being moved to the Quarry, should go elsewhere. This
would be the sort of place where recreationggrounds usually are,
surrounded by gas works, and factories, and rather iut in the tail
end of the town. It certainly can go there. There is no fundamental
difficulty about it. We have something more unusual and more excit-

ing. This thing wants going into further. It may well be that it
is found it is too much of a job, in which case we shall be forced to
a more conventional solution, and no doubt the Recreation Ground will
find itself in this area. If this brain-wave is nothing more we
shall have to solve it in the way suggested by the speaker. Kewstoke
Road : The last thing we want to do is to destroy the character of
Kewstoke Road. We only want it to make it reasonably safe, and it
is important there should be nothing in the way of concrete kerbs
and the semblance of a by-pass about it. It must remain a rural
road. At present it is definitely unsafe in places, particularly
after getting out of the Woods, and out of the Borough area. We think
Kewstoke Road must be reasonably safe for the large amount of traffic
that will use it, but it must remain a scenic road, primarily.
(Applause.)

Mrs. Organ : I am worried about the Hospital. You are to bring
the main road down past the Hospital. I spend a lot of my time in
hospitals, and it is dreadful to think of, all that traffic passing
the Hospital all the time. Why not move it ?

Mr. Brett : The Hospital is not well sited. Like many hospitals,
it has become engulfed by development. The Boulevard will not for
ever be a major road, but I agree in due course a new site must be
found for the Hospital, somewhere on the top of Worlebury--I do not
know if it is too windy--but I will make a note of that. We will
provide for it. Wemust face it that it is a pretty remote prospect
at the moment.

Ms. J Waterson : I have three questions. Will the new enter-
tainments section have sufficient cover for visitors, and do away with

25 The Wheel of Weston-super-Mare on Beach Lawns, photographed by Max McClure (November 2010).

their complaints that wet weather prevents them enjoying Weston ?

Secondly, is there any intention in the new development along the

Front to bring in shops or similar buildings, that Blackpool has, for

instance. I hope not, actually. Third : Is there going to be any

underground pedestrian crossing for these new main arteries, and

for these new main roads into the town ?

Mr. Brett : Certainly no shops along the Sea Front at all.There are

a few shops at present which will disappear under the Plan. There is

the question of subways, and I think the Borough Engineer will inform

him that it is almost impossible, owing to the question of flooding.

I do not think you can make subways under the main roads in Weston.

About the new amusement centre--the Arcade site, I take it. Will it

be a good place on a wet day ? Will it cover all needs ? Neither

of these questions are very easy to answer, because covering all this

is a very vague expression. I think it will provide as many cinemas

as Weston can take at the centre, apart from those it already has.

Obviously, there will be only a few shops and cafes there. It will

be only a minor part of Weston's shopping amenities. In wet weather

it is desirable that shops and cafes in the new Arcade development

should be arcaded ~~xxxxxxxxxxxx~~ over the pavement, so that people can shop without

getting wet. There are limits to what you can do an a wet day. You

are bound to get wet to some extent. The best thing you can do is

ensure that ~~xx~~ any development of that sort is screened from sea wind,

and so, if there is a gale blowing, and sheets of rain falling, you

are out of the wind, and you will be shielded in this square from the

sea wind.

Councillor <u>Procter</u> : May I clear up a point with regard to the
hotel. I do not want anyone to go away with the wrong idea. When
Mr. Brett mentioned during the course of his Plan that it would be
necessary to take a road through the Hospital he was referring to the
one in the Drove Road--the Isolation Hospital and not the General
Hospital. We have had a question sent up by Mr E. R. Yorke. He
akx asks whether it will be possible to bridge the River Axe, and gain
easier access to the Burnham and sitrict areas. I may say the
Council have now, for some considerable period, been trying to resus-
citate the ferry, but, unfortunately, without very much success.
During the War we were requested by the Government to allow a Bailey
Bridge to be laid across at that particular point, and we accepted
their request, but, unfortunately, the Bailey Bridge did not arrive.
The ferry has not arrived, and we are still without that easy access,
which we all need. We have a note from E. Godfrey, and this deals wit
a local subject, and not with the Plan : Large areas of Weston and
suburbs are waterlogged ; in completing the development of these areas
could they either be efficiently drained first and the buildings put
up afterwards, instead of allowing the residents to swim for it as
they have now on the pre-fab. estate. (Laughter.) Whilst in my
own terms this type of question is excluded I can say this : The
housing question was so dire, the necessity of housing people as
quickly as possible was so dire, that we were not able to wait for
the roads to be made before the pre-fabs. were on use but in all
subsequent lay-outs the roads will be made, and the land completely
drained, so that I think in future the question of using lifebelts
will not be required. Mr. Morrell asks if the Goods Station xuld

NAME	DATE of REPORT	PROPOSALS
WESTON-SUPER-MARE TRADES COUNCIL (Contd.)		"modern lines. If this be observed we feel that the existence of light industrial activity would in no way detract from the amenities enjoyed by the town. Members of the Reconstruction Committee will have noted the importance which the Trades Council attach to this particular recommendation. Without work there can be no real life. We suggest with respect that it is the plain duty of every Local Authority to augment every agency which will have the effect of preventing large-scale unemployment. We are clearly of the opinion that Reconstruction proposals in this Borough will be purposeless unless some provision is made in the lines we have tried to indicate."
	
		" Conference Hall This amenity, whilst more specifically concerned with the entertainment of visitors during the summer, would at the same time fill a much needed requirement for all residents throughout the year. The Trades Council urge the provision of this building, which should be a hall capable of accommodating the largest conferences. We consider that the Arcade site, under proper development, and with suitable properties purchased to give a sea frontage would be of great benefit to seasonal activities."
	
		" Citizenship We are anxious that every attempt should be made by the Borough to train boys and girls in a sound outlook towards what is implied in the term "citizenship". We realise that many valuable voluntary bodies are doing excellent work in this direction, but we feel it would be a good thing if the Council offered some tangible encouragement. We suggest that the Council should offer money prizes at appropriate intervals for essays on the principles of Local Government. The competition to be open to all boys and girls still at school, and with of course varying grades for age."
	

- 2 -

26 Page from *A schedule of proposals extracted from Reports submitted by various Organisations and Societies, etc.* presented to the Public Relations Standing Sub-Committee in the Committee Room of the Town Hall (5 March 1945), found in the North Somerset Studies Library on Boulevard (December 2011). The library houses similar consultation reports on other topics, such as: public buildings and baths; parks, parades and sands; public libraries; housing; public health; and entertainments. Those consulted include the Trades Council, the Standing Conference of Women's Organisations, the Rotary Club, the Round Table, the Chamber of Commerce, N.A.L.G.O., and a wide range of individuals.

could be sited at the rear of the Gas Works.

Mr. Brett : I do not think the railway would do that. They are prepared to go some way out with their Goods Station, but you must expect that they will want it as central as the Passenger Station. That is taking it some way out, and it is going to increase their costs enormously, becuase they will have two separate loop lines running out, one the passenger, the other the goods. It was only with difficulty we put over provisionally the scheme that we have put before you to-night on the Great Western. They have not committed themselves to it, but they did not produce any snags. I doubt if it would be possible for me to go to them with this sugges- tion, because I think it would be turned down. I hope this wont be put down, but the Railway Company took a long time to come to a decision. It will be difficult to get a ruling on this quickly. I will think about it, but on the face of it there is very little chance of the Railway Company being prepared to take their Goods Station some way out.

Councillor Procter : I ask you to bear with us for a few minutes. There are two more questions.

Mr. N. Finney : I want to ask two simple questions. Is any money going to be raised for a children's library in the town--a children's reference library, to which children from school can go and make references after their tasks at school ? Secondly, are you going to have a branch library towards Milton, and another towards the Bournville Estate ?

Councillor Procter : The answer in both cases if "Yes." (Applause.)

27 Wrights & Sites, 'Everything you need to build a town is here', 2010, one of 41 signs commissioned as part of *Wonders of Weston*, photographed by Jamie Woodley (November 2010).

<u>Mr. Brock</u> (?) : I think the Excursion Station should be brought
more central, if possible. I know flattening of the loop is very
necessary, but I think it will be worse than it was previously.
People will have to go further for the shopping centre, which is the
part they want to get to, and not through the lime street, Ellenbor-
ough Park. I am sure Mr. Brett will know what I refer to when I
mention the Rye Scheme, with its grass-lawn streets and covered
pavements, and I realise fully the people of that city have squashed
it, which, I think, is rather a great pity ; and would it not be
possible to have High Stree, Regent Street, grass or partly grass
in the centre ? As regards the project of the hotel on the Front.
I think it is a very fine thing indeed and that this meeting should
consider it carefully from an architectural design point -of-view,
and if they are so keen on the Sanatorium they consider that the
Sanatorium could be a hotel. Another thing is the road which goes
up Clevedon Road, at the end of which is the Swimming Pool. I do
not care much for the design of the building, and I consider a
fountain or some mural structure os significance could be placed in
front of it, and, perhaps, in various other situations some fine stat-
uary could be placed. This Station again : I do not like the way
people deposited from the trains have to go over the bridge and cross
five lines, which will be like Gloucester bridge--if any of you know
Gloucester Station you will know what I mean--and have this long way
to go from the Station exit itself. I should like for the tradesmen
and business people that the road should be improved if possible, and
for it to be possible to cycle direct from the Railway Station to the
east part of the town. I feel the Railway are rather poor in their
exit at the moment.

Councillor Procter : I would like to congratulate the young man, because he is one of the few who will see this come into effect.

Mr. Brett : I was going to say exactly the same thing. It is easy to smile about these things, but that is just the kind of help we do want. For instance, the Sanatorium, in due course a new Sanatorium will be built, and I do not think one need be short-sighted about it. Eventually, the old one will be reconstructed. After all, it cannot serve its purpose indefinitely. And then we hope this hotel will be a worthy termination of the southern end of the Sea Front. I think that that is the way we look at that particular problem. There is no doubt the speaker has the main fact : That many Weston buildings are not of perfect architectural design. Maybe, he does not like the design of the Swimming Pool. One has got to accept the Swimming Pool, and one has to accept a great deal of Weston. A great deal can be done with effective grey buildings, to give that cheerful air, by simply colour-washing and using colour in a sensible way. If you put a cream colour it does produce a cheerful, sunny effect, but it will help to make the Weston architecture a little gayer and perhaps less grim. I hope I may be forgiven for using the word colour. There is a lot to be said about the use of statuary, the design of lamp-posts, bollards, etc. There is no end to the details which can make or mar a town. It can be modest, or it can be loud. You may be assured we shall draw attention to these minor things when we get our final report. The Station question : If you walk from the new Station along the Alexandra Parade extension to the town you will be a little longer than it was. It will be so different that I do not think anyone will notice the extra 150 yards. The walk is

Whither Weston

It's for you to say

Hear, Question and Criticise

**THE MASTER PLAN FOR
THE FUTURE WESTON**

to be revealed by the authors

CLOUGH WILLIAMS - ELLIS, F.R.I.B.A., M.T.P.I.
and LIONEL BRETT, M.A., A.R.I.B.A.

at a

Town's Meeting

KING'S HALL

(Locking Road)

Friday, 24th January

Commencing 7 p.m.

ADMISSION FREE

BE SURE OF A SEAT . . A limited number of Tickets
entitling holders to a Reserved Seat until 6.45 p.m., obtainable
—————— at the Public Relations Office, Town Hall ——————

28 Flyer publicising the meeting of townspeople held in the King's Hall (24 January 1947),
found in the North Somerset Studies Library on Boulevard (December 2011).

indirect. You now emerge into an enromous expanse ; you feel you
have come to a place which is not of the slightest interest. You
emerge into an extremely dangerous area outside the Town Hall, and
then, turning right, find your way in a rather tortuous manner to
the Sea Front. I think you will find the ~~distance~~ difference down the long
curve to Alexandra Parade will be only a matter of 150 yards, and
I think it will be forgotten among the trees, flowers and tall,
dignified buildings which we hope to see on both sides. That is the
answer about the Railway Station. We have to accept the loop.
I did not understand the question about the road to the east end of
the town, or the cycle track. I daresay the speaker could come up
afterwards and tell me what he means, Grass centres down the
streets : A great many of the major traffic roads are planned with
central strips. We would very much like them to be wide central
strips, like the new Alexandra Parade and the new Carlton Street.
These answer to our friend's desires. One cannot afford that every-
where, and our central strip, which is invaluable, because it not
only segregates traffic but enables you to raise the highway at cross-
roads, has to be narrow, and has a pavement 4ft. wide, because one
cannot widen all roads as much as one would like. (Applause.)

The Mayor : I feel you would like me, on your behalf, to extend to
Mr. Brett our very grateful thanks for the trouble he has taken in
explaining this "Master Plan" of Weston. I am sure he has taken on
an extra load to-night--on his own side, and that of his partner--in a
way which I feel certain we shall look back in Weston to the beginning
of what we hope will be a brighter and better Weston of the future.
Thank you ! Mr. Brett, on behalf of Weston. (Applause.) On beghalf

of the Council, I would like to thank the townspeople who have come
to this meeting to-night, and to assure you that all suggestions and
criticisms which have been made will be taken into account when the
Council debates the adoption or otherwise of this Plan. Thank you

9.45 very much. Good night.
p.m.

--oOo--

Afterword

Weston-super-Mare, a small seaside town on the south-west coast of England, seems to have been undergoing a process of regeneration for over 150 years. Brunel's Bristol & Exeter Railway reached the small settlement in 1841, transforming the townscape from a lone hotel and a couple of inns into a seaside resort for thousands of workers from the Midlands and south-west England. The Improvement and Market Act of 1842 allowed for the first of a series of visionary redevelopment schemes which have fashioned the town ever since. It is this continuous process of dreaming a future Weston-super-Mare to which artists were invited to contribute as part of a public art programme in 2010.

Weston-super-Mud, as it is colloquially known, has a tidal rise second only to the Canadian Bay of Fundy. The retreating sea exposes mud flats and a wide expanse of beach, which can be treacherous to unsuspecting visitors. Though a thriving Victorian seaside resort, the town suffered from the decline in the seaside holiday in the late-twentieth century. Today Weston wears its best out 'front', while its inner town centre is rarely visited by day-trippers, masking some of its most intriguing qualities: buildings designed by master architect Hans Price are separated from their source of limestone – the Old Town Quarry – by just a few streets. The North Somerset Museum nestling in a backstreet boasts a revolving display of personal collections and artefacts from the Grand Pier fire of 2008 including a cash register replete with melted money. A small door under a municipal car park leads to Weston Market – the town's souk – Weston's community of local traders.

How could a public art programme bear witness to the multiple personalities of Weston-super-Mare: the rose-tinted aspirations of its visitors in search of the seaside Eldorado, the seasonal shifts in the town's daily routines and the divergent experiences and histories of its residents.

This book acts as a complementary frame to 'Everything you need to build a town is here', a project by Wrights and Sites (an artist-academic collective comprising Stephen Hodge, Simon Persighetti, Phil Smith and Cathy Turner) for the public arts programme entitled *Wonders of Weston*. 'Everything you need to build a town is here' challenges the assertion of regeneration to improve upon or to replace what is already in existence. Similarly *The Master Plan* explores imaginative and necessarily hopeful, albeit risky, acts of planning and regeneration through the lens of a small town in North Somerset.

Claire Doherty (CD):
Early in your research process for 'Everything you need to build a town is here', Stephen, you showed me an annotated copy of Exeter Phoenix: A Plan for Rebuilding *by Thomas Sharp. This provided a catalyst for your thoughts about how to approach this artist's book.*

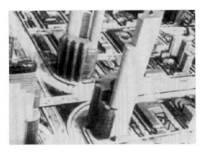

Still from *To New Horizons*, a Jam Handy picture (1940).

Stephen Hodge (SH):
Yes, the book (produced by The Architectural Press in 1946, complete with multiple, full-colour, fold-out maps) was a typical outcome of post-World War II 'planning fervour'. But what separates this particular copy from others in circulation are the marginalia, written by an unknown Exeter resident. The annotator documents the actual urban development over a twenty-year period from 1955 to 1976 as an appendix to Thomas Sharp's speculative Master Plan for Exeter. The narrative is, of course, highly personalised and geographically centred on the author's home to the south of the River Exe, but it seemed to me to hold within it the distance between the planner's vision for the future and the inhabitant's response from another future.

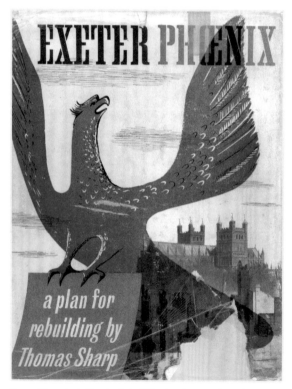

Exeter Phoenix: A Plan for Rebuilding by Thomas Sharp (1946).

Weston, too, was seduced by the possibilities afforded by the late 1940s planning wave. As part of Wrights & Sites' initial 'field' research for our commission, I discovered a 1978 newspaper obituary for architect Clough Williams-Ellis in the North

Somerset Studies Library, which referred to his Master Plan for the town.

A year later, in preparation for this book, it seemed important to return to the library and dig deeper. Perhaps I was searching for Williams-Ellis' equivalent to Sharp's weighty strategy for the redevelopment of Exeter. Instead, what I found buried away in a folder (labelled 'Town Planning – A/BWG 4/138 pt 1 – 1944 – Post War Reconstruction') was a rather provisional and unassuming document with a handmade, cut-and-paste cover bearing the words 'Weston-super-Mare' and 'The Master Plan'.

This document was never made public in written form. Instead, it remained a makeshift transcript of notes, on Abermill Bond paper, taken by a town clerk at a public meeting held in Weston's King's Hall on 24 January 1947. Full of gaps and errors, it feels far more pregnant and full of hope than Sharp's plan for Exeter. As Williams-Ellis was unable to attend the meeting due to illness, the main presentation is made by his partner Lionel Brett (it is likely that Brett did much of the legwork on the plan anyway). This presentation is framed by comments from His Worship the Mayor, Councillor G. E. Bosley, and by the Chairman of the Works and General Purposes Committee, Councillor Proctor. Questions from the public, as well as verbal reactions to the plan, are recorded in the text. The transcript reads to some extent like a dramatic script. At one point, Councillor Proctor deflects an attempted coup by a Mr. H. W. Haydon. There are verbal errors made by Brett. There are visible typed mistakes and strikethroughs in the transcript, clearly not intended for publication, which also bears subsequent penciled edits and highlights by a more senior council figure.

In making this document public in its entirety 65 years after it was originally filed,

Underwood Universal Portable Typewriter (c. 1947).

I took one moment in Weston's history as a kind of trigger for a set of comments back and forth between text, image and document over time, so, like the annotated *Exeter Phoenix*, the master narrative of Weston might be challenged through the small and seemingly inconsequential.

CD: Your annotations are highly visual but not illustrative – a collection of reconnaissance photographs taken while exploring the town, along with found documents, audio transcripts, objects and texts, which extend beyond the context of Weston. How did the reconnaissance photographs come about?

SH: Wrights & Sites use reconnaissance walking as a research method. The porosity of walking as a means of understanding place and the people you encounter is central to our practice.

For 15 years now, we have employed disrupted walking strategies as tools for playful debate, collaboration and spatial meaning making. Our published Mis-Guide series (*An Exeter Mis-Guide*, 2003; *A Courtauld Mis-Guide*, 2003-5; *A Mis-Guide to Anywhere*, 2006) are not touristic instruction manuals. Guided by the practice of mytho-geography, they place the fictional, fanciful, fragile and personal on equal terms with 'factual', municipal history. In Vienna, we worked with artists and non-artists to produce 16 tours for the city's rubbish dump, tram system, crime scenes, street furniture and so on (*Stadtverführungen in Wien*, 2007). In Haldon Forest Park, we reimagined the forest, walking with specialists in geography, architecture, psychology, choreography, organisational development, design, scenography and virtual worlds (*Possible Forests*, 2007). Our work facilitates dialogue between the walker-artist and the walker-participant, who will become partners in ascribing significance to place. There is latitude in the work: it is not closed, but offers a set of provocations and perspectives, with space for the participants to fill in their own specifics and make their own connections.

In preparation for 'Everything you need to build a town is here', the whole of Weston became our territory, to walk and re-walk – not just the seafront and the central business district, but also the residential streets, the industrial areas, the nooks and crannies, and the blurred edgelands of the town. Similarly, in piecing together this book, *The Master Plan* transcript has been my terrain, and I have attempted to reconnoitre the text by way of a number of routes.

CD: You use the transcript of The Master Plan *as a spine for the book, holding this diverse set of references, but the content of the historical document appears surprisingly*

Walking on a snow-covered beach, Weston-super-Mare (2010).

'Studies show that nine out of ten new mayors begin their careers with a frenzy of destruction, using monsters, earthquakes and other disasters to reduce their cities to rubble. After that's out of your system, we'll move on the real challenge of building a thriving metropolis.'

Dr. Wright's Urban Planning Guide', *SimCity* manual (1991).

contemporary. Despite its anachronistic language, the plans for open spaces, sustainable transport and housing renewal are familiar to us in 2012.

SH: Labour's Town and Country Planning Act 1947, which redefined UK planning, was passed in the same year as the meeting in the King's Hall. In fact, the Rt. Hon. Lewis Silkin, Minister of Town and Country Planning visited the town on 13 August 1947 to open the *Design for Weston* exhibition, and dined on ox tongue and veal in aspic with Williams-Ellis. This year, on 27 March 2012, the Tory's major overhaul of planning legislation, the National Planning Policy Framework, took effect.

CD: The Sea Change programme was funded by the Commission for Architecture and the Built Environment (CABE), which was subsequently disbanded after the General Election of 2010. Subsequent to the relaunch of Weston's rebuilt Grand Pier and the newly refurbished seafront, the funding crisis hit North Somerset Council. Even within the relatively short period of time in which these works were developed for Weston-super-Mare and the publication of this artist's

book, there has been a perceptible shift once again in national and local government policy towards regeneration and the cultural agenda. What story do you see emerging in this book?

SH: There's something in Weston which is replicated across many other UK seaside towns – a tension with the regeneration agenda with layers of nostalgia knocking against layers of inspiration and imagination. A place in constant flux where (perhaps unrealisable) plans rise to the surface, and are gradually eroded away. But, there are always outliers of hope from which to gain perspective: the hope of Weston's foremost Victorian architect and chess fanatic Hans Price, as he 'planned his opening gambit on the town's checkerboard'. Of Williams-Ellis, best known for the 'fantastic acropolis' that is Portmeirion, backdrop to 1960s cult TV-show *The Prisoner*. Of Ashley Parsons' battle for access to the water tower at the former RAF Locking. Of postcards home. Of giant telescopes, and of model villages. Of Technicolor worlds, and of *SimCity*, where we can all be master planners. Of the rupture of the lived experience and the genius of the place.

Notes on Wonders of Weston

Situations, in association with Field Art Projects, produced *Wonders of Weston* in 2010 as part of a broader redevelopment programme in Weston-super-Mare for Sea Change, a national regeneration initiative. The selection of seven artists and architectural practices to respond to the town reflected a desire for the programme to encompass a broad range of creative approaches – from sculptural to performative, architectural to conceptual or text-based.

Wrights & Sites conceived of 'Everything you need to build a town is here' as a constellation of 41 signs dispersed across public gardens, the museum, car parks, restaurants and allotments throughout the town. Each of the signs refers to aspects of architecture in Weston – whether grand, municipal, amateur, accidental, forgotten, part-demolished or imagined – and contains a carefully worded instruction, observation or comment, designed to encourage the reader to conduct an action or thought experiment. The signs accumulate through their dispersal to form a highly ambitious call to public imagination, which might be seen to fracture the promotion of a single marketed identity for Weston-super-Mare.

The island form of Steep Holm, which punctuates the horizon view out to sea from Weston, was particularly resonant for artist Tania Kovats, commissioned to work with landscape architects Grant Associates, and Studio Weave, whose shortlisted design for the Tourist Information Centre (TIC) was based on a short story of unrequited love between the TIC and the island. The oval concrete form of the 1930s Model Yacht Pond formed the frame for Ruth Claxton's sculptural installation 'And My Eyes Danced'. Lying on the south-west expanse of beach, near to the derelict Tropicana lido, the pond was designed to be filled naturally by the sea at high tide and originally used for sailing model boats. Claxton's dynamic series of overlapping rings in three formations with circular glass panels reflect the changing light of the sky above.

Other works transformed aspects of Weston's architectural environment through subtle interventions: Lara Favaretto created a constellation of phosphorescent material along the Marine Causeway, which dissects the sea from the artificial Marine Lake, whilst Tim Etchells' short text fragments etched into the glass of a beach shelter, commemorate and articulate the desires, frustrations and silent gestures that accumulate to form a day in the life of Weston. In 'Winter Piece', Etchells installed two statements – 'The Things You Can't Remember' and 'The Things You Can't Forget' – in blue neon on the façade of the Winter Gardens pavilion, a direct call to Weston resident and Weston tourist, from the beach ranger to the tea dancer, to consider the unremarkable. Raumlaborberlin sought out the overlooked spaces of Weston, drawn to Weston Market by what they called its 'very British character'. The market offered a potential live set, source of props and objects for their John Cleese Academy, along with the Silly Scope, a temporary kaleidoscopic pavilion.

To read interviews with the artists and for full details on the locations of the permanent works in *Wonders of Weston*, visit www.wondersofweston.org.

THE MASTER PLAN
Stephen Hodge

A Wrights & Sites Satellite Project

Published by Book Works and Situations
Distributed by Book Works

Book Works: Co-Series No. 1

ISBN 9-781906-01-238-0

Edited by Claire Doherty
Coordinated by Katie Daley-Yates
Proofreading by Gerrie van Noord
Design by Polimekanos, London
Printed by Die Keure, Bruges

This publication forms part of *Wonders of Weston*, a programme of public art commissions produced as part of the national Sea Change programme (2008–2010), managed by the Commission for Architecture and the Built Environment (CABE) on behalf of DCMS. The programme was curated by Claire Doherty, Situations, and Theresa Bergne, Field Art Projects, produced by Situations and managed by North Somerset Council.

www.wondersofweston.org

We are grateful to the following for their help and assistance with this publication:

North Somerset Council
The University of the West of England
Ruth Claxton
Tim Etchells
Raumlaborberlin
Max McClure
Jamie Woodley
Weston Library

The Master Plan is reproduced here with permission of North Somerset Council.

Book Works, 19 Holywell Row, London EC2A 4JB, www.bookworks.org.uk, T +44 (0)20 7247 2203
Situations, Spike Island, 133 Cumberland Road, Bristol BS1 6UX, www.situations.org.uk, T +44 (0)117 930 4282

SITUATIONS BOOK WORKS ARTS COUNCIL ENGLAND North Somerset COUNCIL FIELD | ART PROJECTS

Front cover image: Weston-super-Mare reconnaissance, photographed by Stephen Hodge.
The 'sandcastle' shadow cast by the Grand Atlantic Hotel at sunrise (April 2010).